INFERNVM

THE ART OF JASON ENGLE

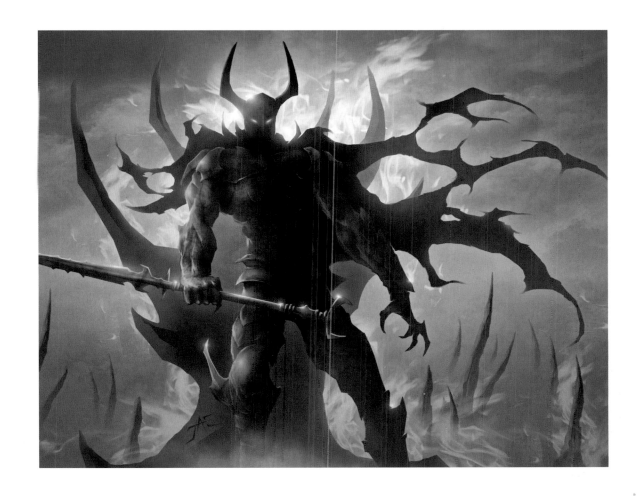

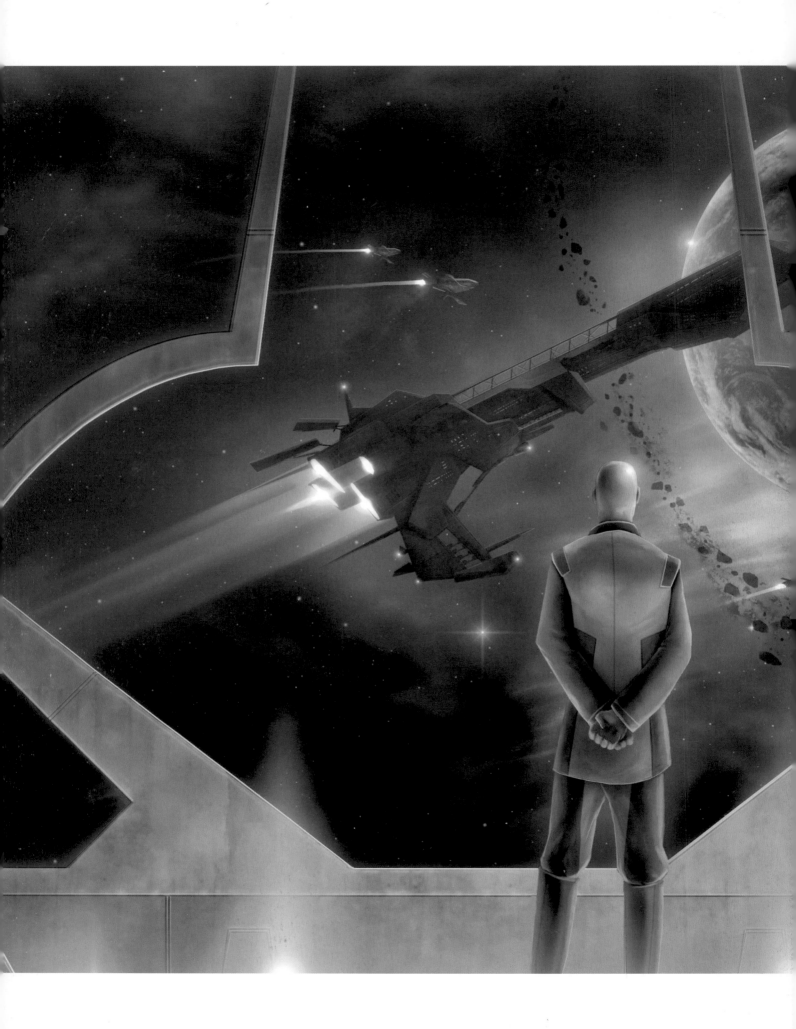

INFERNUM

THE ART OF
JASON ENGLE

First published in Great Britain in 2004 by
Paper Tiger
The Chrysalis Building
Bramley Road
London W10 6SP

An imprint of **Chrysalis** Books Group

Distributed in the United States and Canada by Sterling Publishing Co., 387 Park Avenue South,
New York, NY 10016, USA

1 3 5 7 9 8 6 4 2

British Library Cataloguing-in-Publication Data:
A catalogue record for this book is available from the British Library.

ISBN 1 84340 203 3

Commissioning editor: Chris Stone
Project editor: Miranda Sessions
Designed by: Anthony Cohen

Reproduction by: Mission Productions, Hong Kong
Printed and bound by: Times Offset Ltd, Malaysia

Page 1: **ABYSSAL OVERLORD**, 2001, Digital, 12 x 8 in, AEG, 4 card/Promo image

Page 2–3: **STAR LEGION** detail, 2002, Digital, 8½ x 11 in, Hero Games, Cover to 'Star Hero'

Page 4–5: **MERCENARIES**, 2003, Digital, 21 x 5½ in, AEG, Warlord CCG

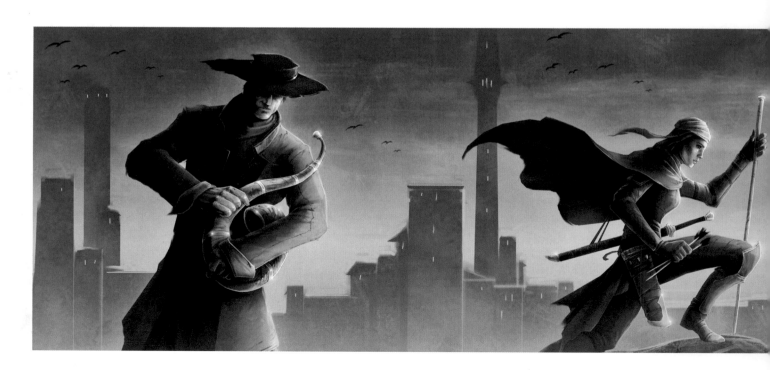

Contents

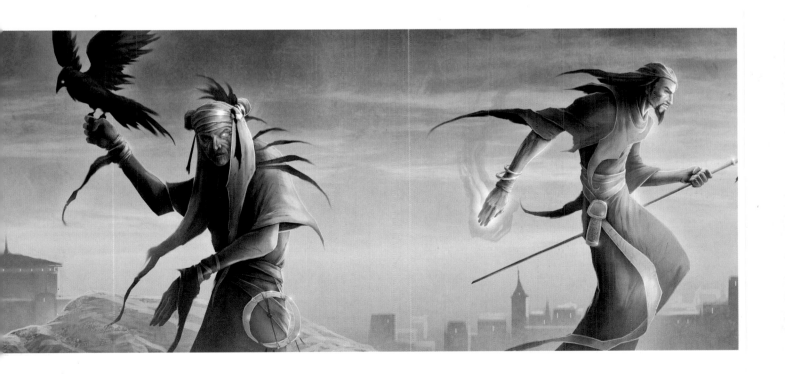

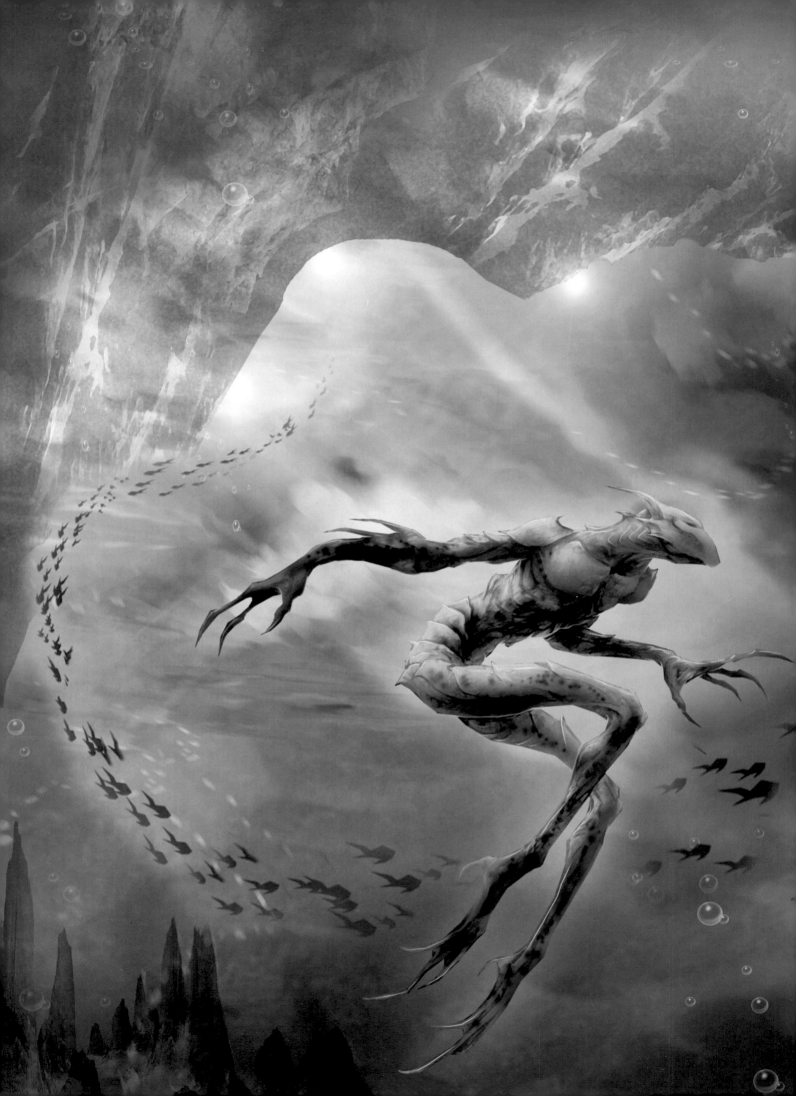

Origins

Left and facing page:
BENEATH THE ICE
1999, Digital, 8½ x 11 in
Obsidian Studios, 'Shards of
the Stone: Core'

This was the second of the full
page, colour images I painted for
the 'Shards' line, and was easily
one of the most entertaining
pieces I've ever done. The game
was still being developed at the
concept stages and the only
directives I had were to create
an image for a fantasy 'water'
world. And in all, from sketch to
finished painting, it took me
about four hours to complete.
I often find that the more fun
I'm having on an image, the
faster it comes to an end.

I have been making art professionally, in one medium or another, for about six years although I have been making art as a hobby for most of my life. I knew at a very young age that I wanted to be an artist and pursued that goal with every free moment.

Born in southern California in 1979, I was raised by my very encouraging and supportive parents on a ranch in Arizona until the age of 18. I never attended a major university or art academy of any kind, and I've always found the best teacher in art to be experience itself, so with that in mind, I found a job in commercial art and design and moved to Florida to begin my career. Now, this is not an indication that Florida is a good place to start an art career, quite the opposite in fact, but it did have one major thing in its favour: there was a company there willing to hire me. Also, it has lots of beaches.

The main reason I found a job so quickly was that I had become a frequent contributor to a number of online gaming communities, and found a lot of opportunities to use my artistic talents for a number of amateur projects and low profile game development. I had developed a level of reputation for

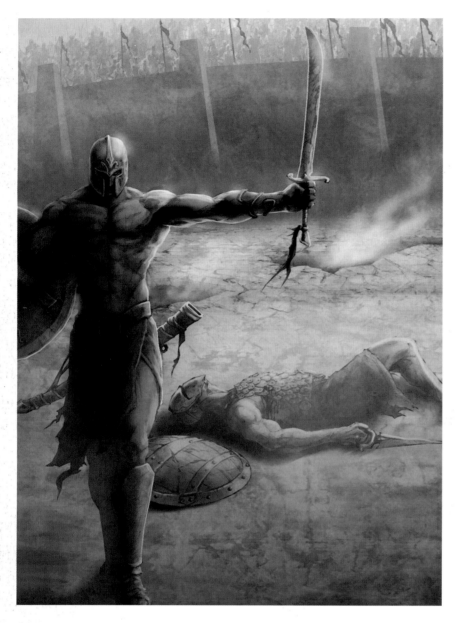

GLADIATOR
1998, Digital, 5 x 7 in
Obsidian Studios, Interior for 'The Roleplaying Gamer's Bible' (second edition)

Facing page:
SOLITAIRE
2001, Digital, 8½ x 11 in
Hero Games, Cover to
'Ultimate Super Mage'
(unpublished)

I always enjoy the chance to broaden my horizons and experiment with new styles whenever possible. Digital art allows for so many major variations in style by making very minor alterations in the art process and method.

The problem with having an established career is that people expect a very defined and recognizable style from you, and in most cases that is the primary basis for their choice of artist in the first place. This leaves the artist with fairly few requests to paint anything that is outside the realm of their obvious specialization.

This was the exception to the rule, and all that it required was a slight familiarity with comic colouring, combined with a few of the techniques that I've used over the years, to produce something that is both appropriate for the genre and polished enough to stand out on the shelf next to more painterly and intricate covers.

professional quality work, in a less than professional field, and it wasn't long before I was contacted by an individual who would soon become my employer.

A man by the name of Jared Nielsen contacted me after seeing my work and offered me a job with his new internet/games company, Gameverse. At the time I was 18 years old and still living on the ranch I had grown up on, so it was an opportunity I was hardly going to pass up. In less than a month, I had signed all the paperwork and moved to Florida to begin my new career as a graphic designer and part-time game illustrator.

It was at Gameverse that I first learned the techniques and software that I use as the basis for my work today, and it was also where I met my first opposition to the very idea of digital illustration as a viable and realistic option in creating quality art. I had worked with digital art software since I

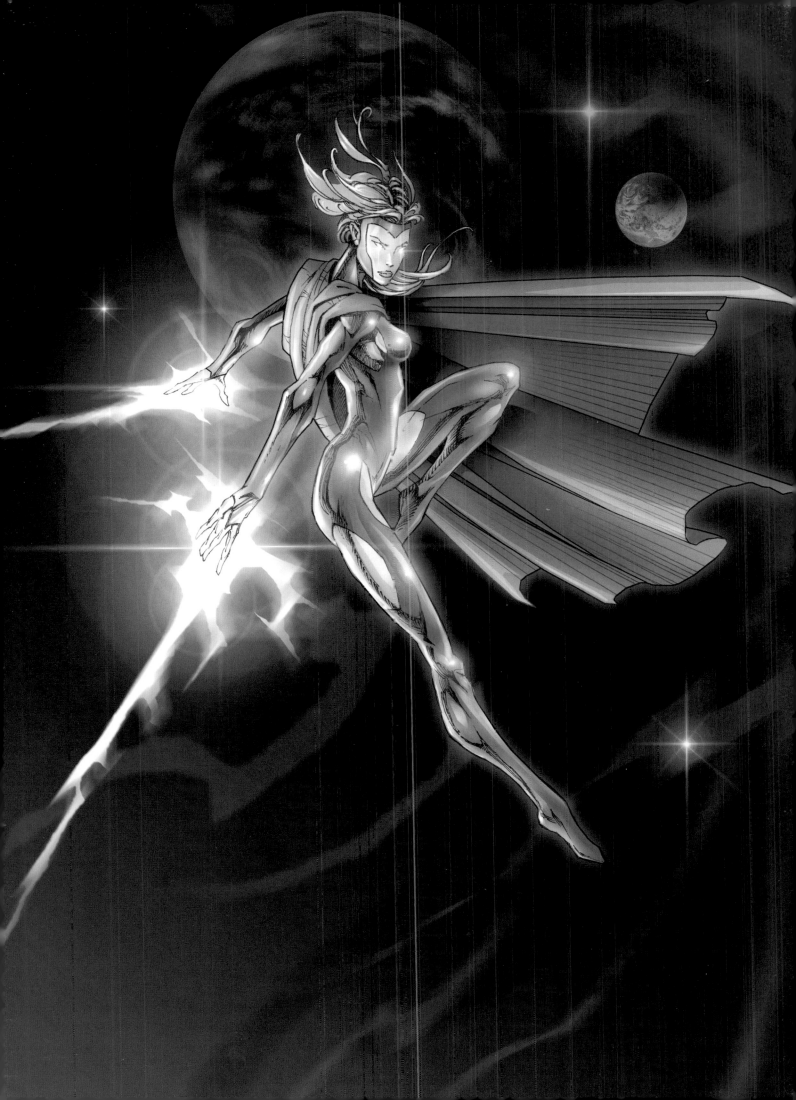

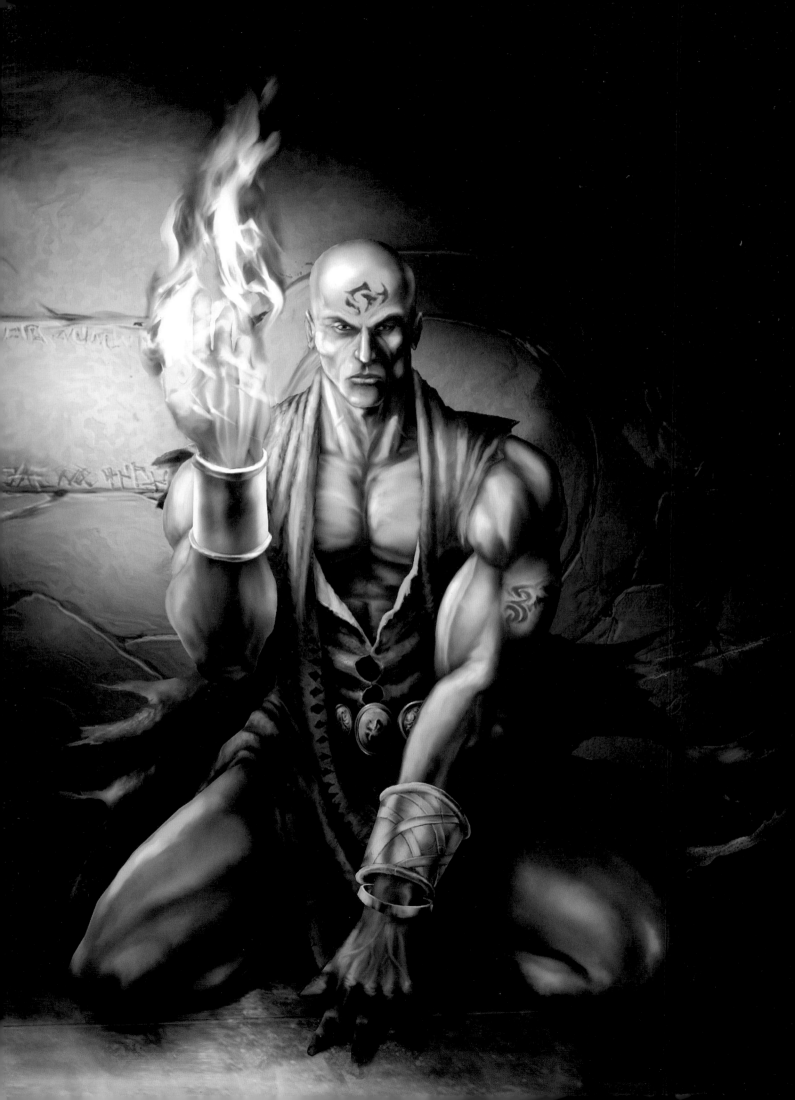

BORGPRINT
1998, Digital, 5½ x 9 in
Obsidian Studios, Interior for 'The Roleplaying Gamer's Bible' (second edition)

GUNMAN
1998, Digital, 3½ x 7 in
Obsidian Studios, Interior for 'The Roleplaying Gamer's Bible' (second edition)

was five years old and was very aware of the limitations of the medium. The scepticisms that I encountered initially did not interest me in the slightest as I knew exactly what I, and the digital medium, were capable of producing. Working at Gameverse taught me quite a lot about graphic design, commercial art, and corporate politics.

Within a year of moving out on my own I had managed to land my first book cover (in addition to my day job) and worked on it in my space time. It turned out okay, and that led to more and more illustration work until I had developed a somewhat respectable portfolio.

And it wasn't long before I decided that the corporate world wasn't a very productive environment for the necessary skills of an illustrator. But, as it turned out, my observations were something of an unnecessary conclusion.

Facing page: **FIREMAGE**
1999, Digital, 8½ x 11 in
Obsidian Studios, 'Shards of the Stone: Core'

This was my first real success with digital paint, and it was done long before the 'Shards' project was even begun. It acted as a kind of flagship image for the project once production was underway and was eventually included in the book for this reason alone as it doesn't illustrate anything terribly consequential to the game or story. It took nearly two weeks to complete and I painted it with painstaking detail (most of which is lost when printed at page size) but I learned a great deal from the experience and originated many of the digital painting techniques that I still use today.

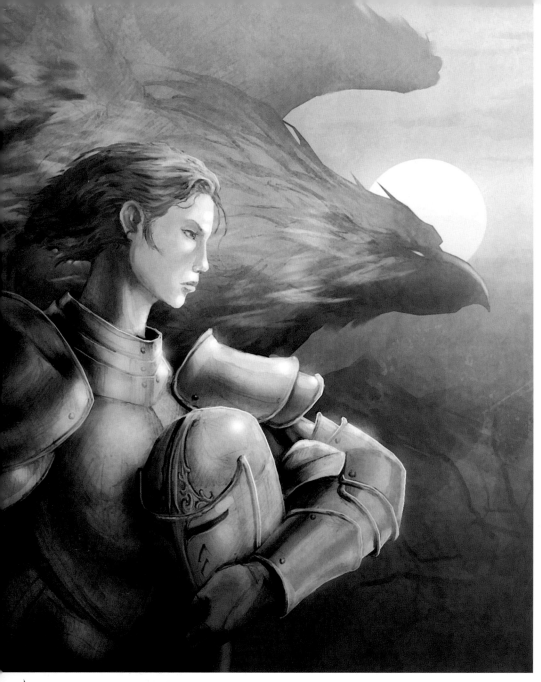

KNIGHT'S SHADOW
1998, Digital, 5 x 6 in
Obsidian Studios, Interior for 'The
Roleplaying Gamer's Bible' (second
edition)

Gameverse suffered from rather shaky corporate backing, and the enthusiasm of the controlling investor was waning fast. So Jared Nielsen, the then president of Gameverse, chose three of the most valuable of his employees, including myself, his best salesman, and our best graphic designer, and invited us to join him in founding a new company, leaving the crumbling remnants of our abandoned venture to the corporate wolves. We were more than happy to accompany him.

And thus, Innovative Studios was created.

innovative

It seemed as though we had left the corporate world with the best of intentions but had found ourselves adrift in the world of financing and had to work very hard just to make ends meet as an independent studio. It was during this time that the first internet revolution was in full swing, and we found ourselves in the midst of many very lucrative projects which led us farther and farther away from our original goals of producing game related products. But, as is so often the case in the world of business, the almighty

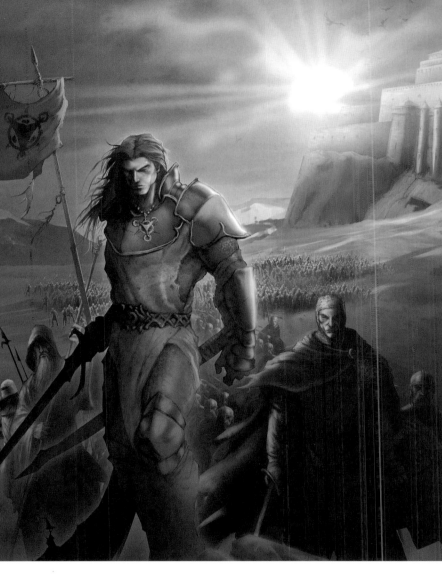

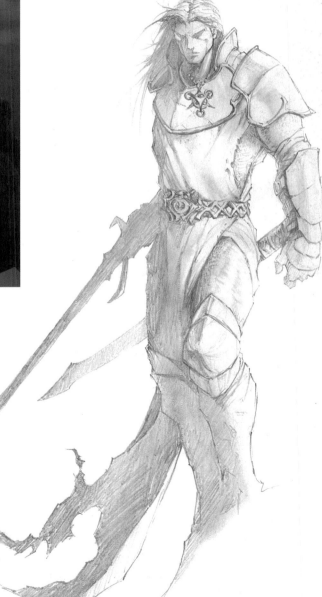

TEMPEST
1999, Digital, 8½ x 11 in
Obsidian Studios, 'Shards of the Stone: Core'

dollar took precedence over our long-time dreams and ambitions of entering the entertainment industry.

So, as a last resort to retain some semblance of our original intent, we created Obsidian Studios.

OBSIDIAN

When the production on our various entertainment projects had reached something of a complete halt, we decided to create a subsidiary with games and entertainment as its sole purpose and direction. We called this new branch of the company Obsidian Studios, and began the long journey of game creation in earnest.

Our first book wasn't actually even a game product, but rather a book about the games industry called 'The Roleplaying Gamer's Bible' (second edition). The lead writer we had hired for Obsidian Studios, Sean Fannon, had written the first edition years earlier, and we had decided to produce

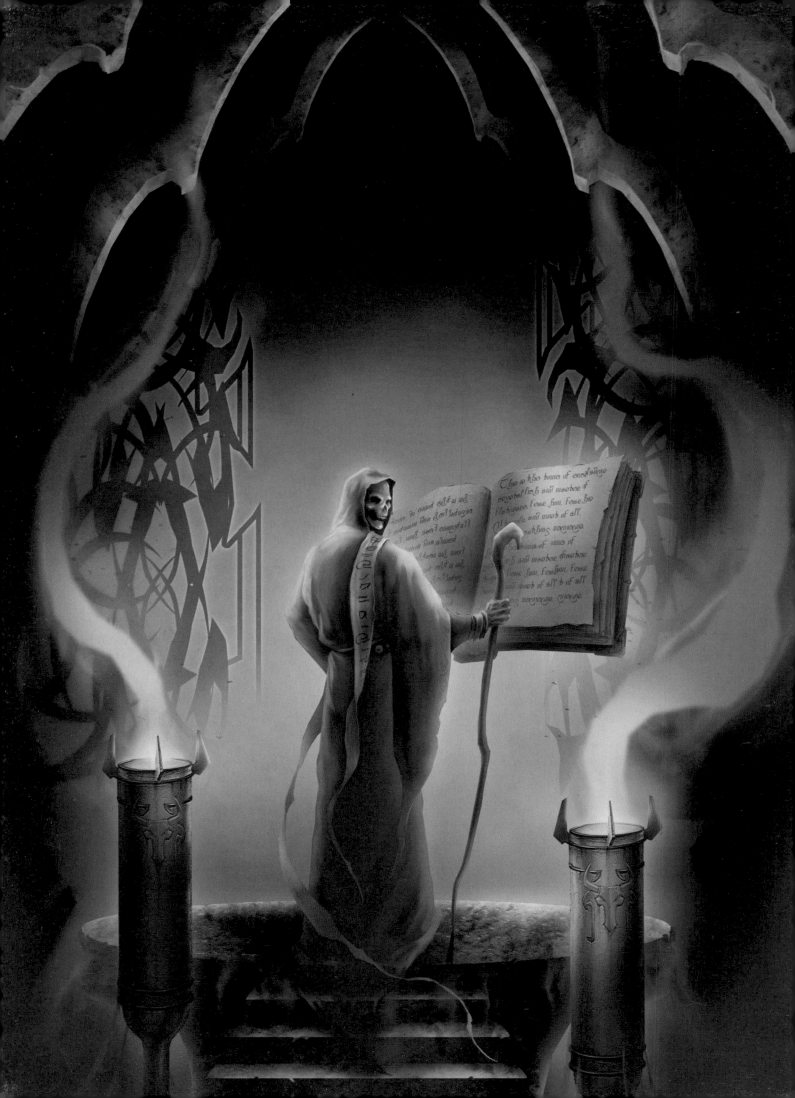

LOW FLYERS
1998, Digital, 7 x 3 in
Obsidian Studios, Interior for 'The Roleplaying
Gamer's Bible' (second edition)

a sequel as a simple matter of product recognition to help establish our new company in the minds of our new fanbase.

For that book I created illustrations relating to every genre of the gaming world, from high adventure to wild west, mystical fantasy to dark sci-fi, and I really had the chance to experiment and further develop a real illustration style and learn a lot about illustration and basic composition through a kind of speed-learning gauntlet of production art. It also taught me a lot about what a real production pipeline is like for an illustrator and how much work is really necessary to complete an entire project with only my own talents to draw on. It was a good learning experience and the hard lessons learned would come in handy very soon. During the time I was working on this book, I was still doing work for Innovative Studios projects, as well as a more games industry business related subsidiary Jared had created called Game Codex, which meant that I was simultaneously acting as sole illustrator and Art Director for three separate companies. For those of you who have never worked in the industry before, let me just say it wasn't the easiest thing I've ever done.

This was obviously a difficult situation to manage and, at the age of 19, I was required to learn a level of responsibility that otherwise would have eluded me completely. I often wonder what kind of person I would have become had I chosen instead to pursue a college degree, and spend the next four years of my life alternately going to classes and partying. I guess I'll never know, but I can't say that I particularly regret it.

SHARDS OF THE STONE: CORE

Our next endeavour was to complete the roleplaying game we had begun when we first founded Innovative, a system that was originated by Jared.

We worked on the book while dividing our time between companies (for what seemed like decades) but after a little over a year it was nearly finished. Convention season was fast approaching and we knew we had to have the book done in time to premiere at the big conventions, or put off the release until next year, which simply wasn't an option. So during the last week of production, we stayed at the office and worked straight through for nearly

Facing page: REVELATION
2000, Digital, 8½ x 11 in
Obsidian Studios, Interior for 'Shards of the
Stone: Tangia' (unpublished)

eight days straight. No showers, barely any sleep, and just pizza to keep us alive. I don't think I could eat any pizza for at least a month after that. And no showers for a week at a time is rather disgusting. I don't recommend it.

But at GenCon the game was a huge success, so it had been actually worth it after all (well, mostly). We sold unprecedented numbers of books and posters for a debut company, and the art received much attention and praise, and we couldn't have been happier.

In fact, the game was such a success that Obsidian Studios received an offer from another game company, who wanted to purchase us and our newly finished game. And after reflecting on the real-world problems of budgeting, overheads, and production costs that would have kept us in debt for some time to come, we decided we could always start a new game company down the road, so we sold it.

The only complication was, they wanted me and the main writer of the game, Sean Fannon, to go with the company to California.

So we went.

CYBERGAMES

The company that had purchased us was located in my home state of California, which I had not seen for almost ten years. I was more than happy to go back, and from the first moment I stepped off the plane it felt like home. It wasn't long before Cybergames was making a large impact in the gaming industry, purchasing major companies and very recognizable game licenses, including Pinnacle Entertainment and their Deadlands game, as well as the legendary Hero Games, and their Champions line. We seemed to be at the very pinnacle of opportunity, and just at the breaking point of success and an ultimate tidal wave of profitable product. But sometimes in life it seems that when the sun shines brightest, midnight is just around the corner.

The funding behind Cybergames eventually ran low, much sooner than we could have reasonably expected, and soon we began to lose valuable employees to budget cuts, including some of the original founders of Hero Games, and easily some of the most veteran members of our small company. It was at this time that I began to seriously pursue my side career as a freelance illustrator.

And after a short while I realized that I was getting enough work on the side, that working under a company banner simply wasn't necessary for me anymore, so I left and began my freelance career.

Most artists in the games industry, or any competitive field for that matter, usually have to spend several years working in the proverbial trenches, taking whatever work they can find, and doing it for low or sometimes no pay at all, simply to get enough experience and recognition to raise their status in the business.

Doing the work that I did really allowed me to establish myself relatively quickly, and avoid paying the dues that most artists pay. It wasn't always easy to be the only artist on so many projects, but in the end it did better prepare me for a solo career, and gave me the discipline and project experience necessary to work as a freelancer. I'd always known I wanted to be an artist when I was a child, and I couldn't have imagined a better way to start my career.

And I had just turned 21 years old.

SERVANT OF THE LIGHT
2000, Digital, 8½ x 11 in
Obsidian Studios, Cover to 'Shards of the Stone: Shaintar' (unpublished)

During our play test sessions for the shards game, I drew many different characters and creatures that later made an appearance in the final art of the core book. This particular image is an illustration of the character that I had played in those sessions. Having the opportunity to include your own character in the final material is occasionally one of those perks of game design, and art direction in general.

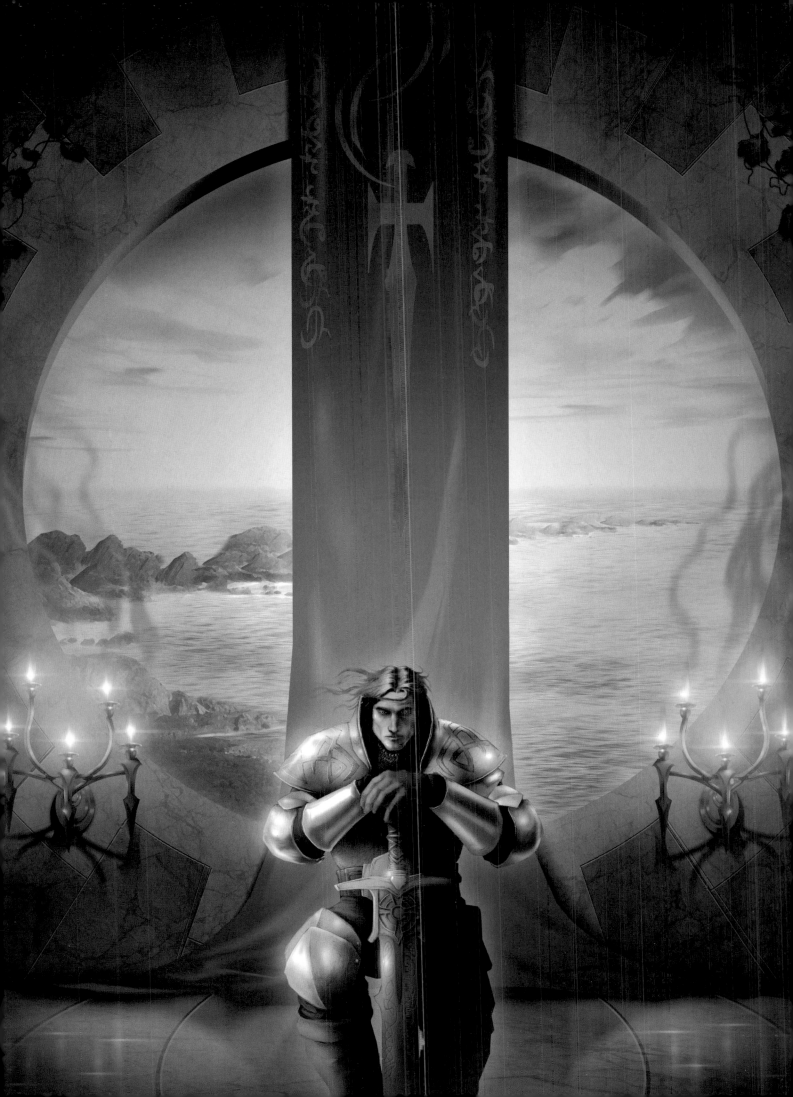

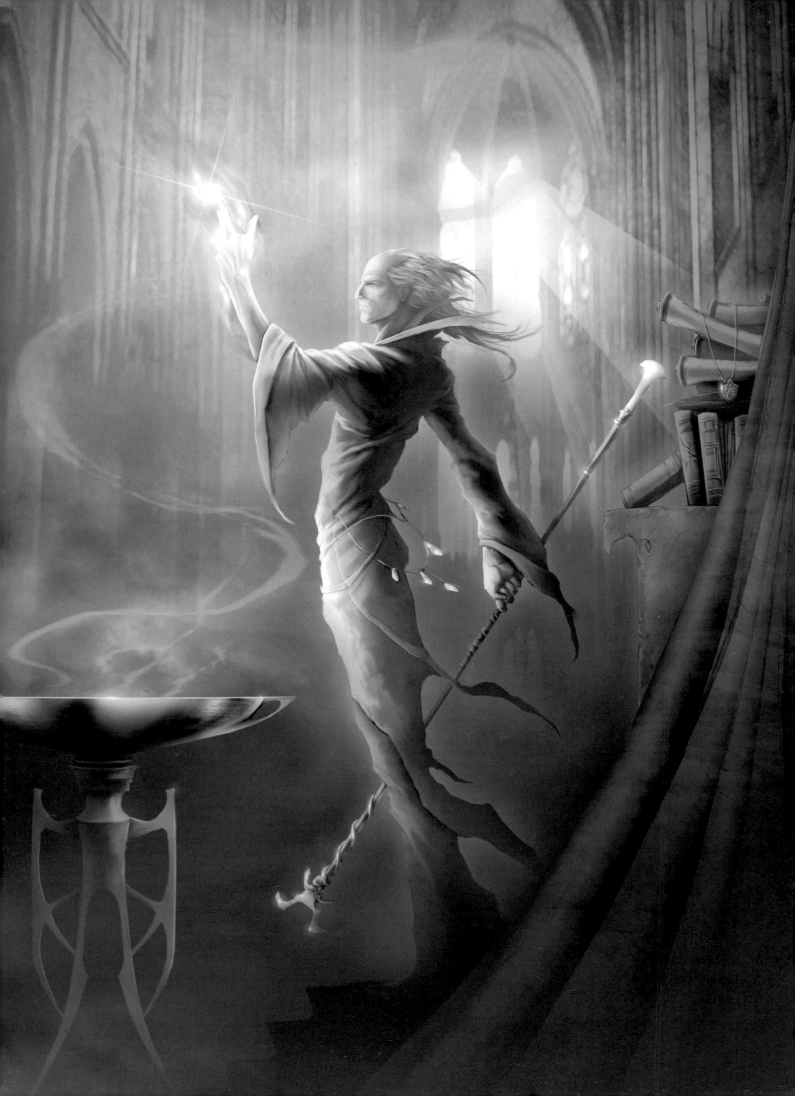

BOOKS

Book and game covers are always a new and exciting challenge. There is always an incredible amount of material to draw on from the product, and often the publishers or authors have lots of great ideas to share. There's never a shortage for creative options, the hard part is picking one direction to best represent the product, and create something that will communicate to the consumer in a way that is as direct and appealing as possible.

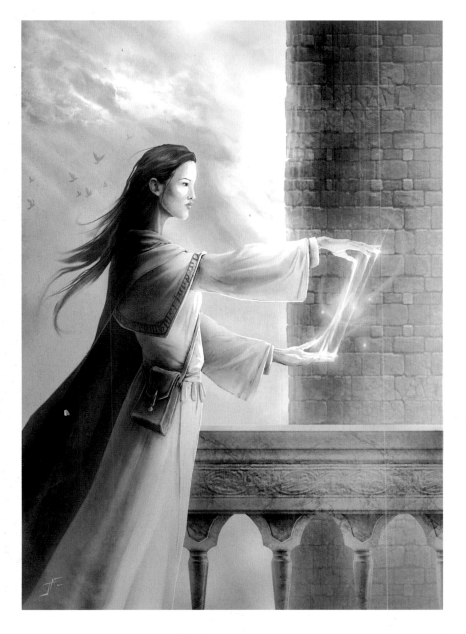

ACADEMY SORCERER
2003, Digital, 5 x 7 in
Sovereign Press, 'Dragonlance: Age of Mortals'

Growing up, The Dragonlance novels were some of the first genre material I was exposed to, and have held a certain nostalgic inspiration for me ever since. When I was still learning to draw, I used a number of the books and calendars as reference and inspiration, absorbing everything I could from the work of some of modern fantasy's greatest artists and illustrators. So you can imagine the thrill I felt when the art director for Sovereign Press called and asked me if I was interested in working on the new material for the line. I would have done it for free!

Facing page: **TOUCH OF MAGIC**
2001, Digital, 8½ x 11 in
Green Ronin Publishing, Cover to 'Arcana: Societies of Magic'

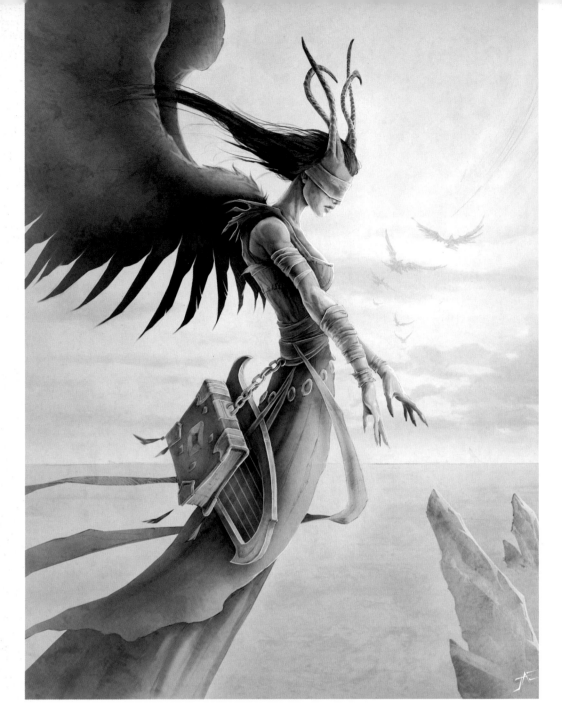

Facing page:
LAIR OF THE BEAST
2003, Digital, 8½ x 11 in
Bastion Press

PENANCE
2002, Digital, 8½ x 11 in
Bastion Press, 'Oathbound: Plains of Penance'

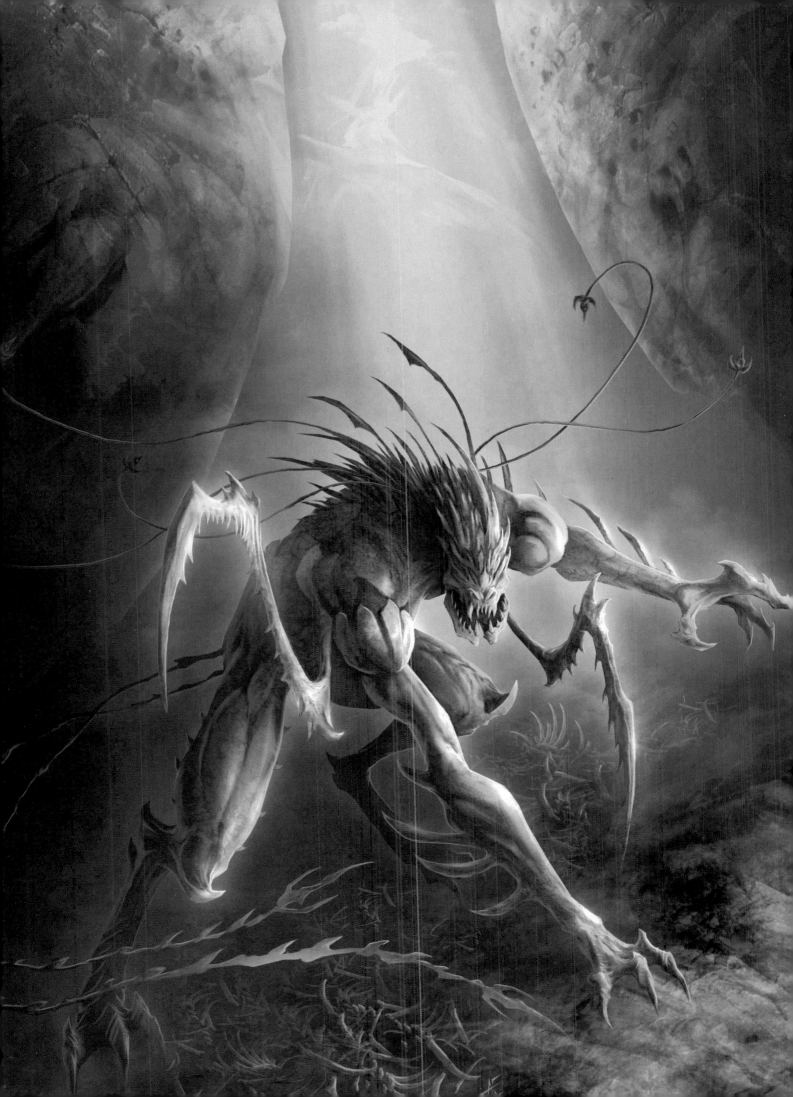

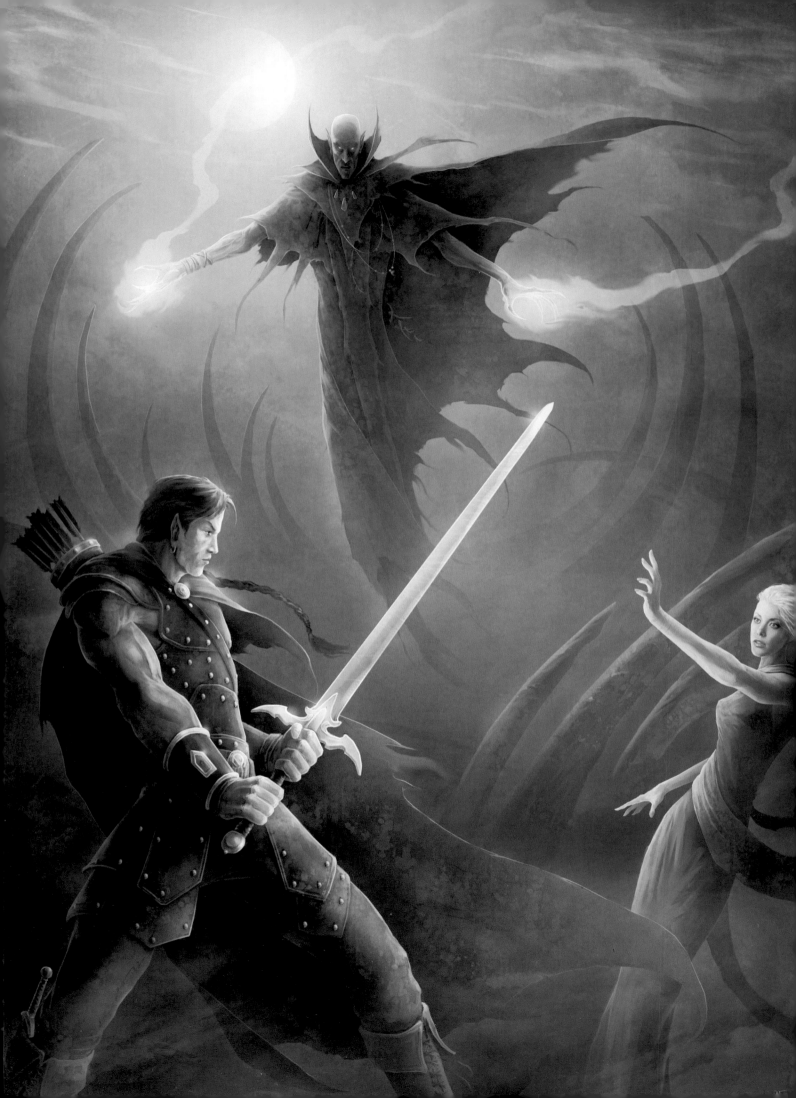

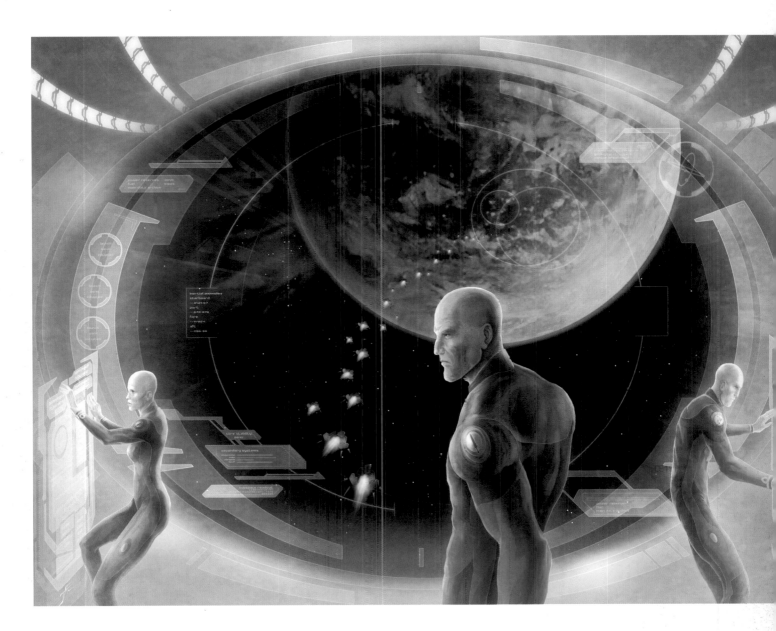

FOURTH MILLENNIUM
2003, Digital, 11 x 8½ in
La Mancha Games, cover to '4th Millenium'

Facing page: **SACRIFICE**
2003, Digital, 8½ x 11 in
Personal Commission

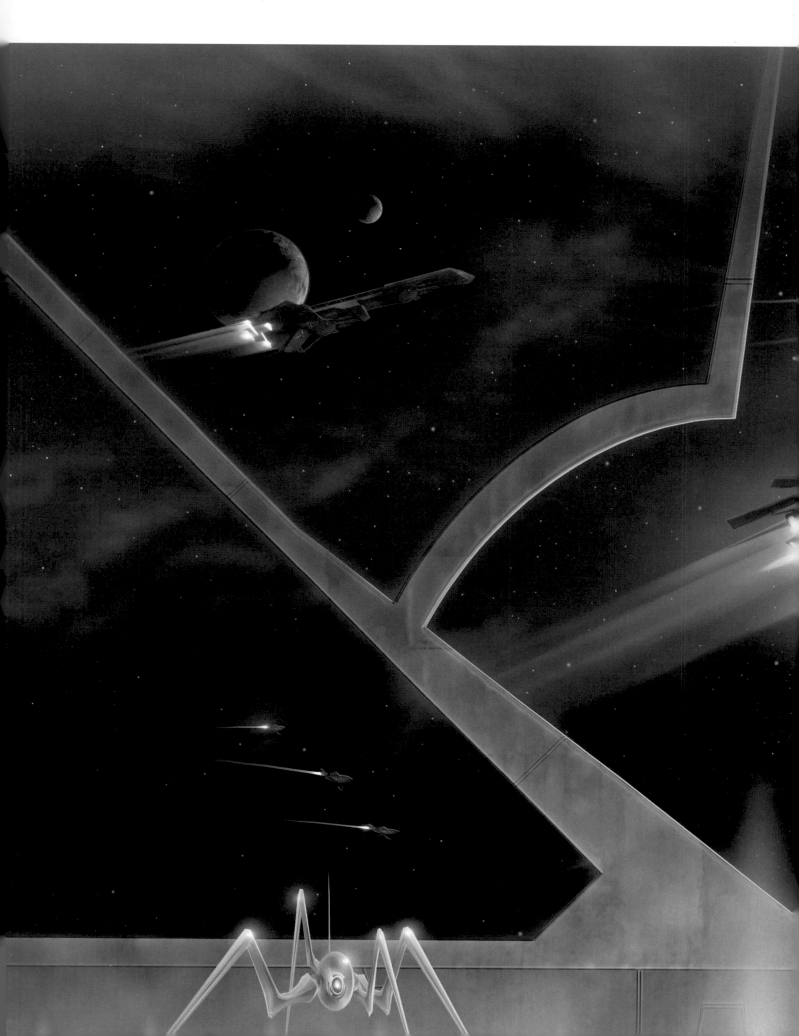

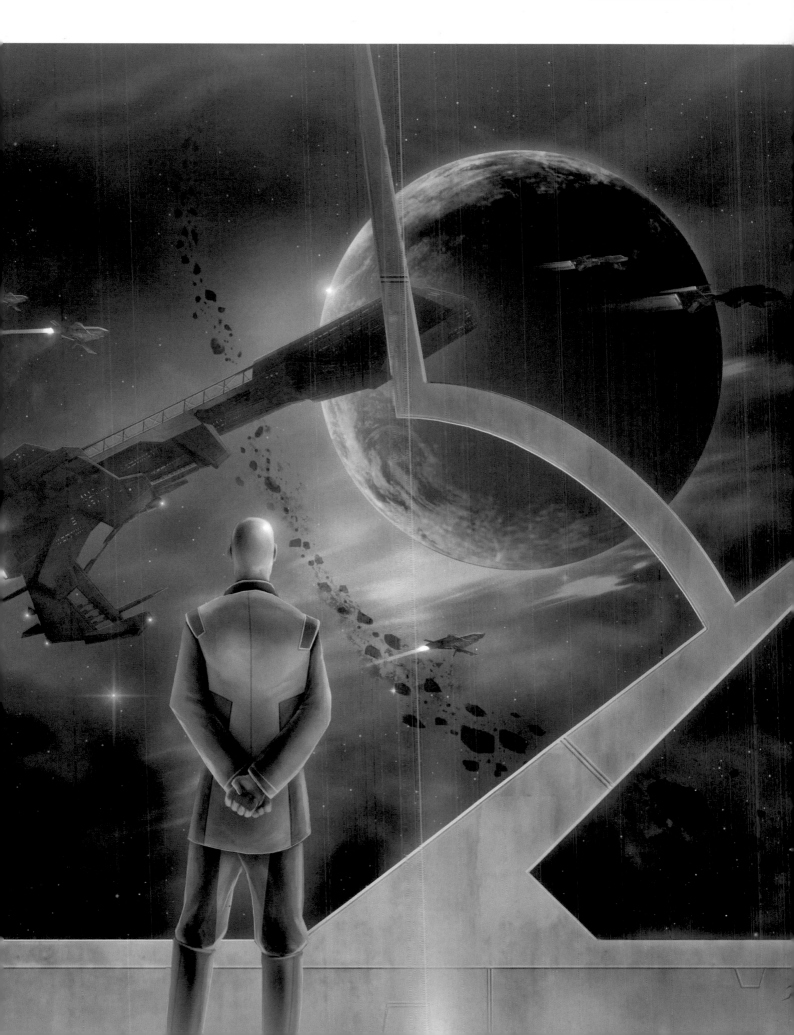

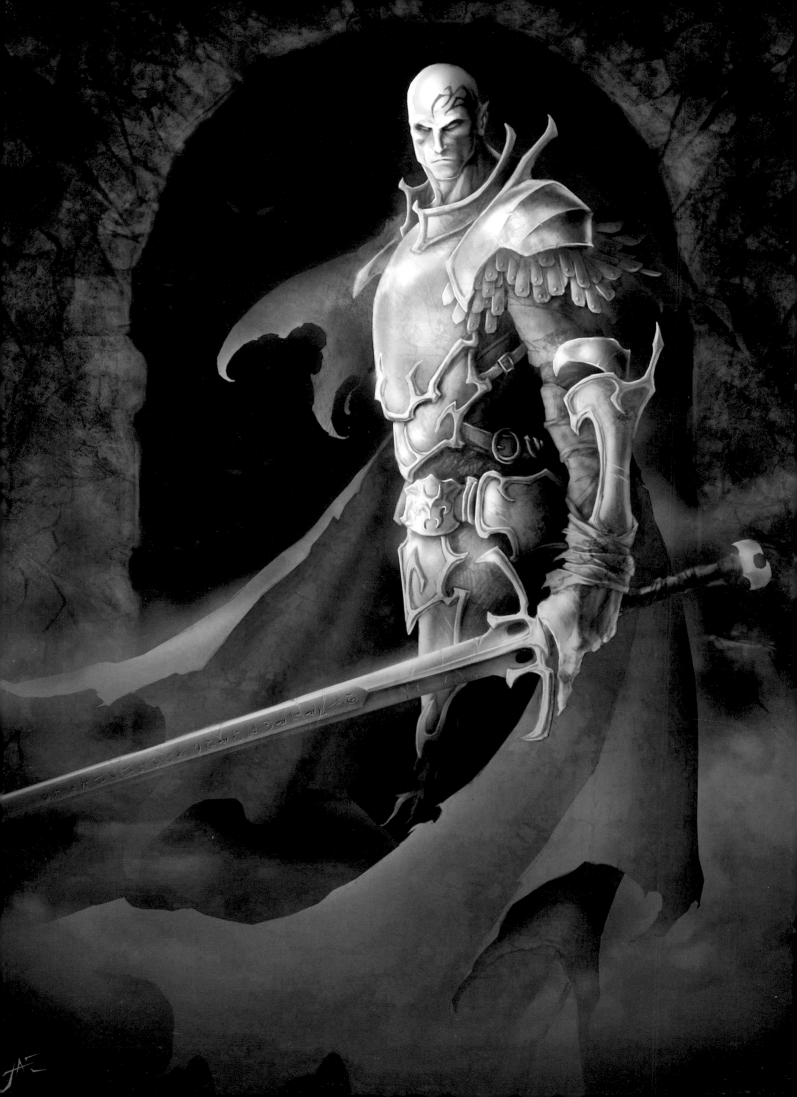

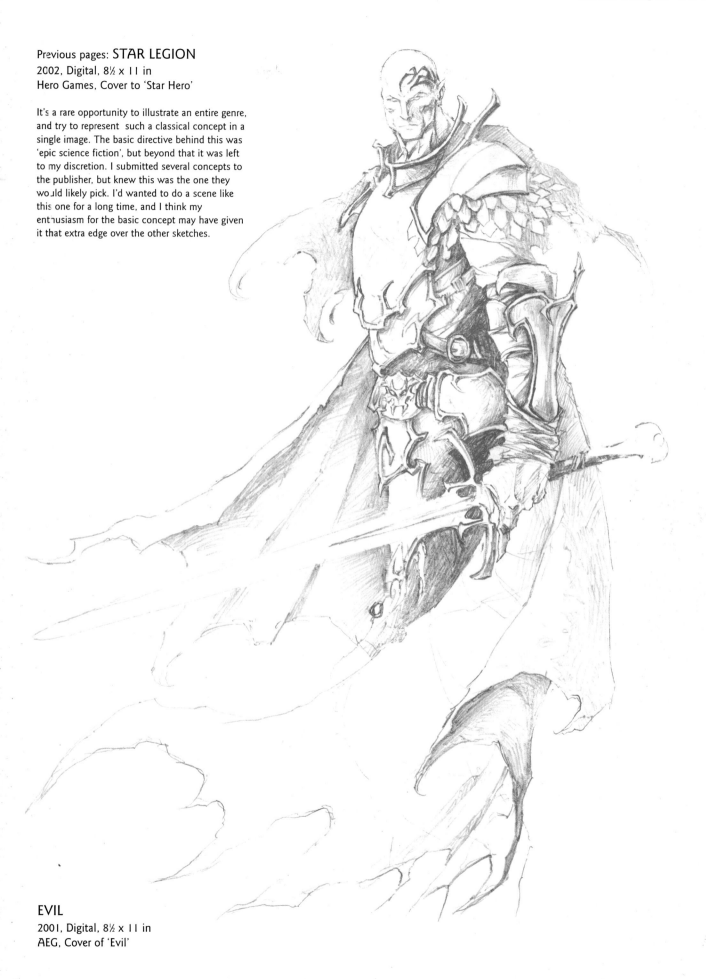

Previous pages: STAR LEGION
2002, Digital, 8½ x 11 in
Hero Games, Cover to 'Star Hero'

It's a rare opportunity to illustrate an entire genre,
and try to represent such a classical concept in a
single image. The basic directive behind this was
'epic science fiction', but beyond that it was left
to my discretion. I submitted several concepts to
the publisher, but knew this was the one they
would likely pick. I'd wanted to do a scene like
this one for a long time, and I think my
enthusiasm for the basic concept may have given
it that extra edge over the other sketches.

EVIL
2001, Digital, 8½ x 11 in
AEG, Cover of 'Evil'

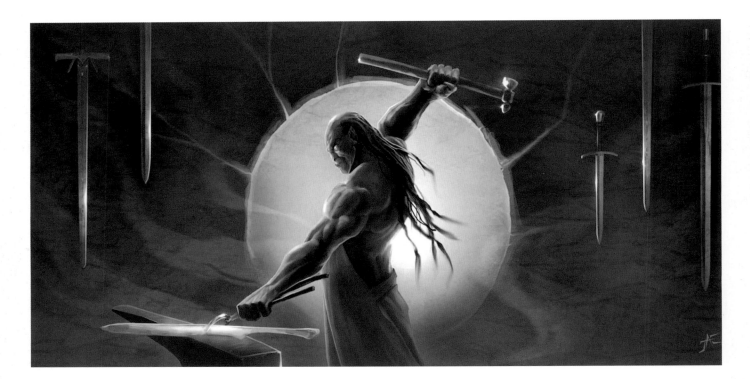

BLOODFORGE
2003, Digital, 8 x 4 in
Mystic Eye Games, back cover to 'Foul Locales: Beyond the Walls'

One of those rare images that took no sketching time whatsoever, the image simply materialized as soon as I read the description. I knew the forge would form a nice circular backdrop, and I'd wanted to draw a smith hammering away at his forge for some time, so the pose was already worked out as well.

Facing page: REALMS OF WONDER
2003, Digital, 8½ x 11 in
Action Studios, Cover to 'Realms of Wonder'

Every once in a while, as was the case with this image, clients will commission me to do a cover when they have very exact specifics already in mind. When working with such defined guidelines, it can be both a curse and a blessing. From an artistic standpoint, I'm left with only a little room to make the image my own, but without the usual effort required by such concerns as composition, perspective, flow, and so on, I'm left with much more time than I'm accustomed to, to consider and re-work the details of the image as they present themselves. I'm equally proud of such work as anything else I've done, but it does require a slightly different approach.

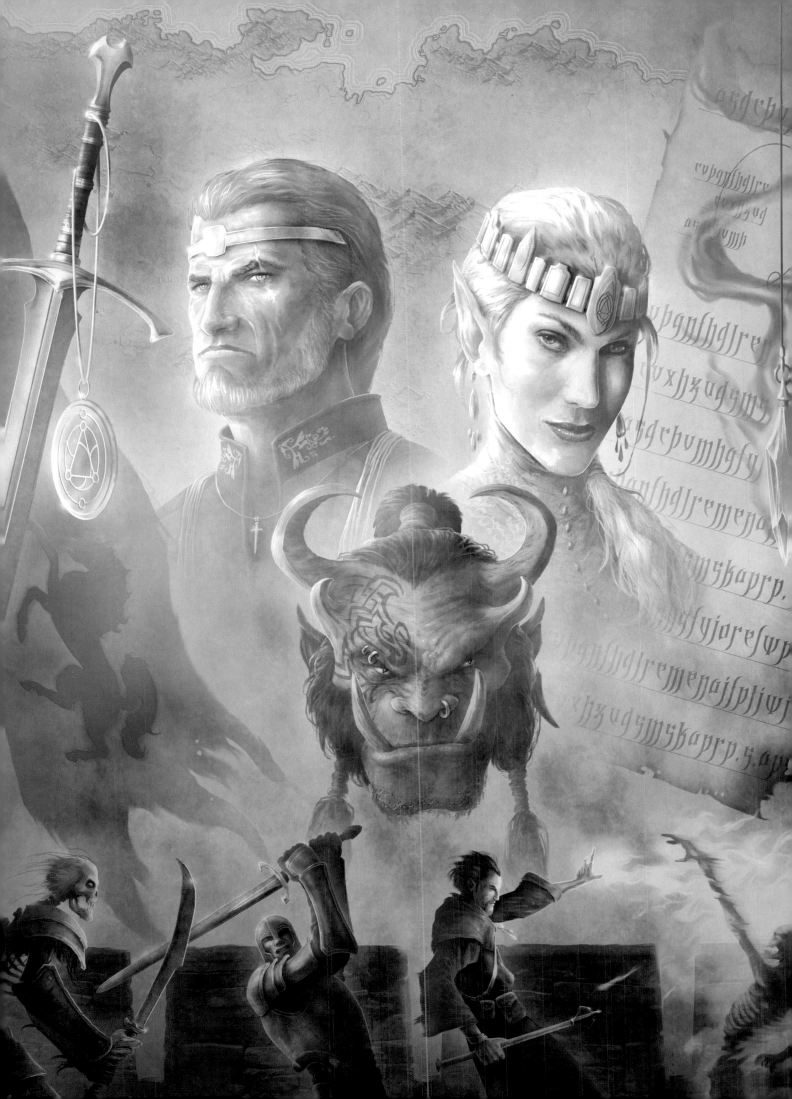

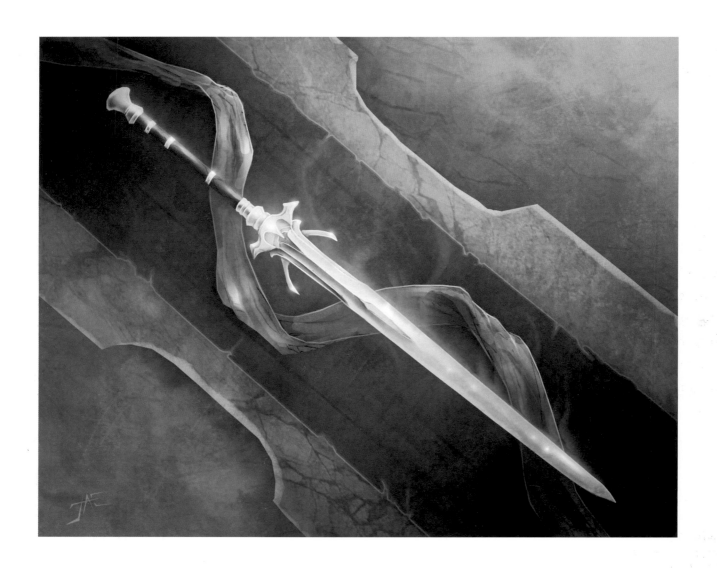

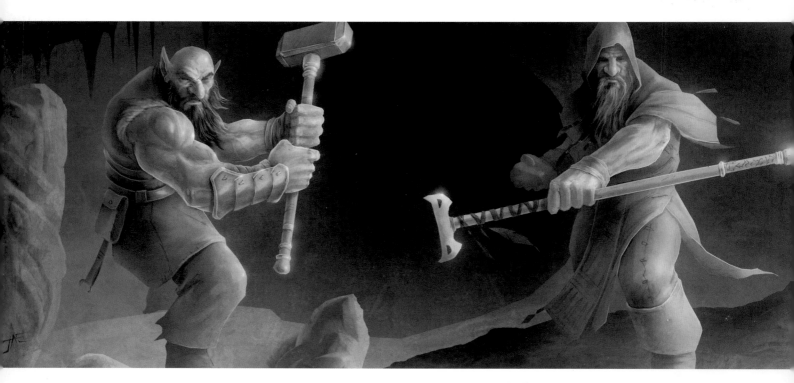

CARD GAMES

◆ was first contacted by AEG to do work for their
relatively new card game, Warlord. I had never done
work for cards before, and had to devote a bit of time to
adjust to the requirements of smaller image sizes and
somewhat horizontal compositions, but soon found it to be an
incredibly rewarding medium.

I have since had hundreds of different card images to
produce, in many different games, and as such have found
many opportunities to experiment in different ways, some of
which have been good, and some not so good. I have
included the successes, and excluded most of the failed
experiments, which I hope to forget as soon as possible.

Facing page: **BLADE OF LOST GODS**
2003, Digital, 7 x 5 in
AEG, Warlord CCG

DWARVES
2003, Digital, 28 x 6 in
AEG, Warlord CCG

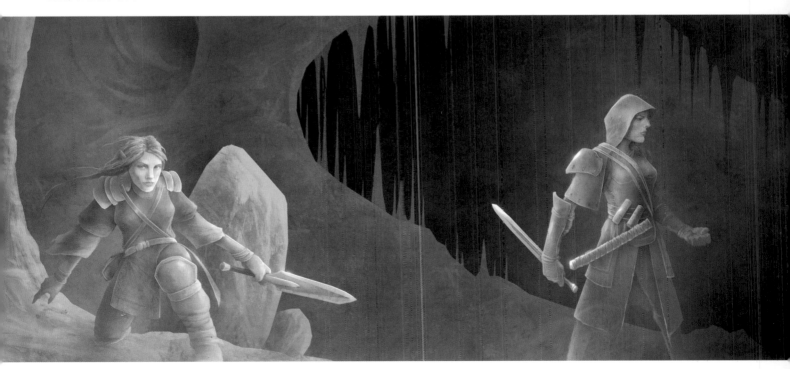

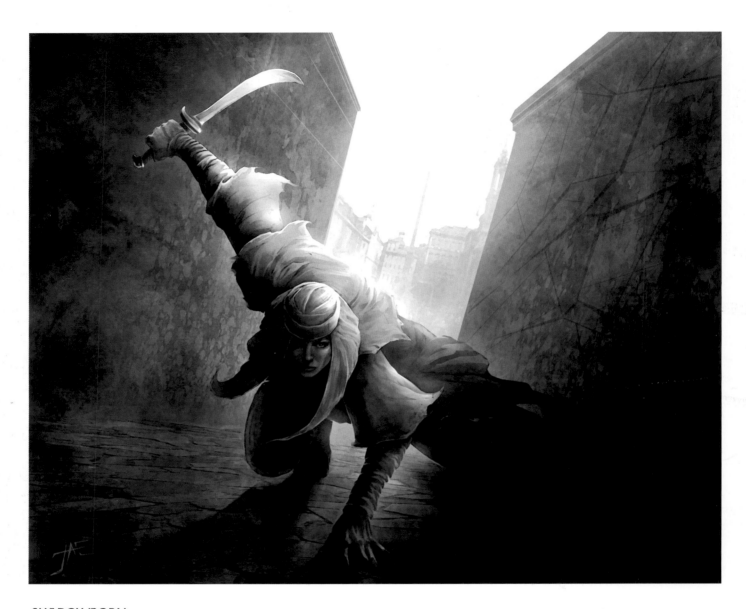

SHADOWBORN
2003, Digital, 7 x 5½ in
AEG, Warlord CCG

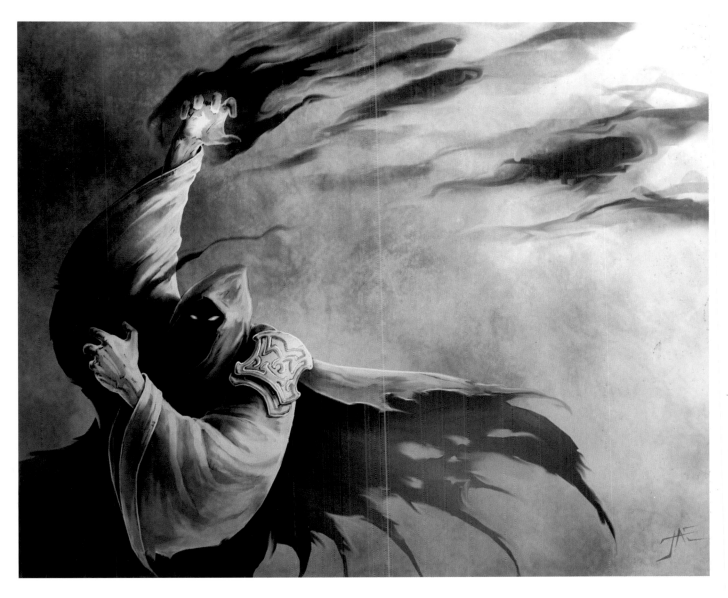

SHADOW BOLTS
2003, Digital, 7 x 5½ in
AEG, Warlord CCG

ABYSSAL EMPEROR

2001, Digital, 7 x 5½ in
AEG, Warlord CCG

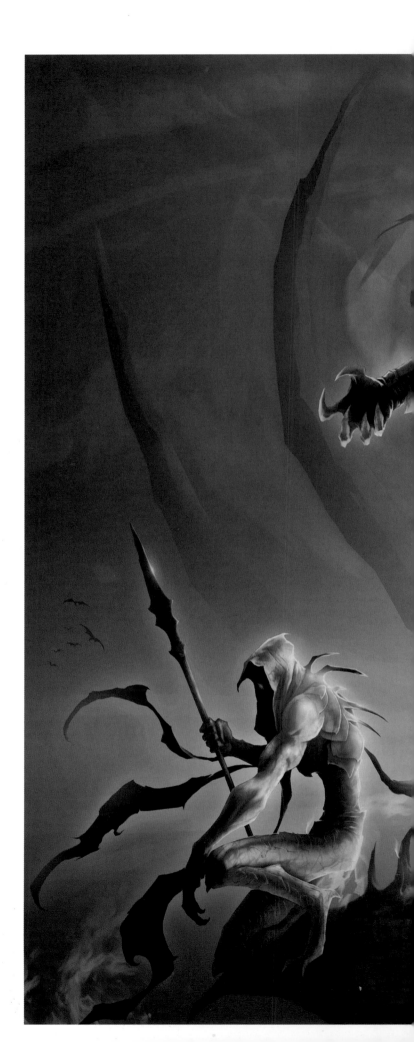

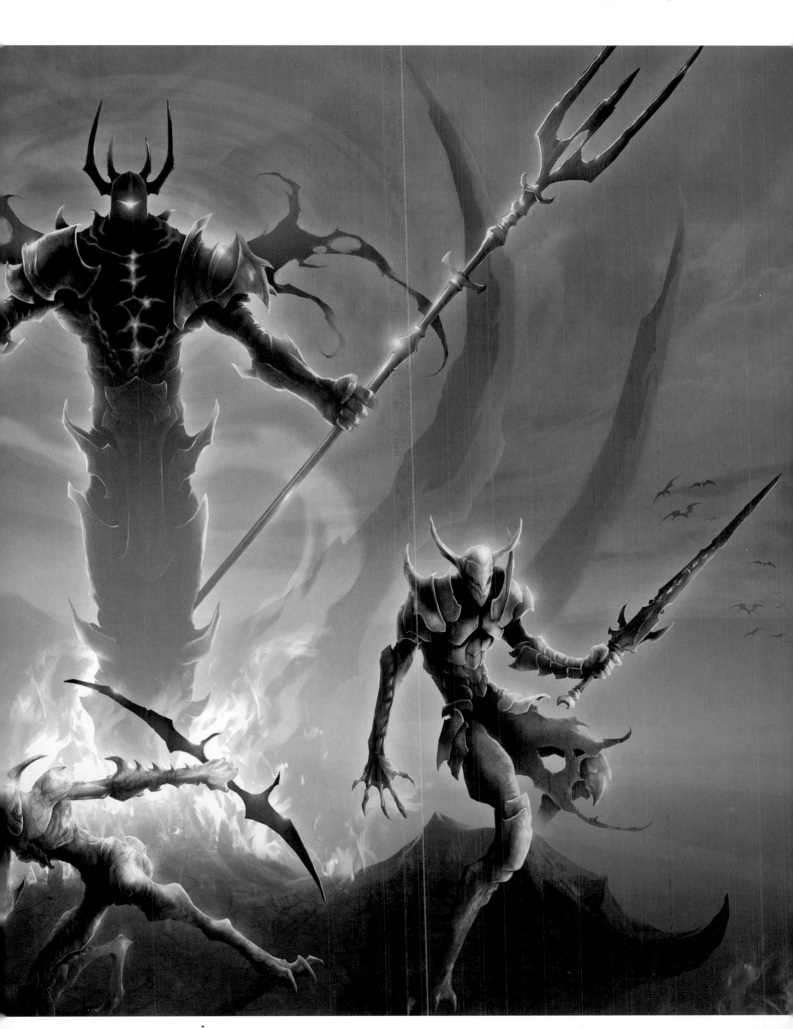

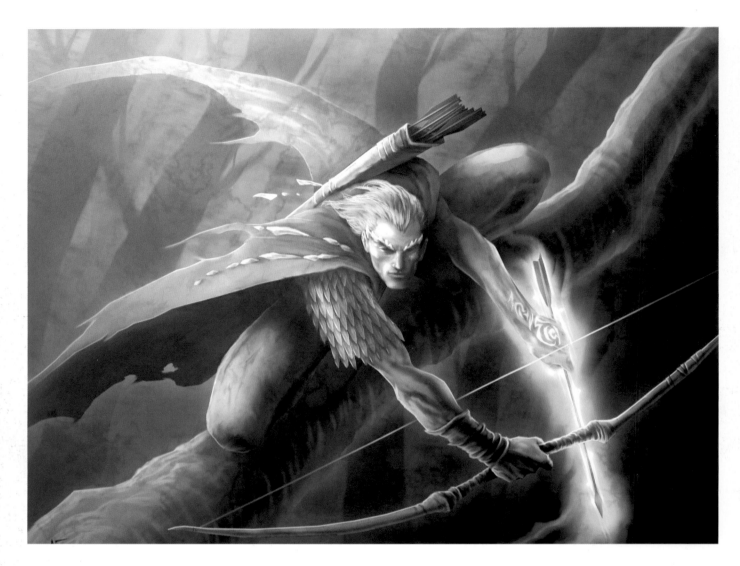

ARCANE ARCHER
2002, Digital, 7 x 5 in
AEG, Warlord CCG

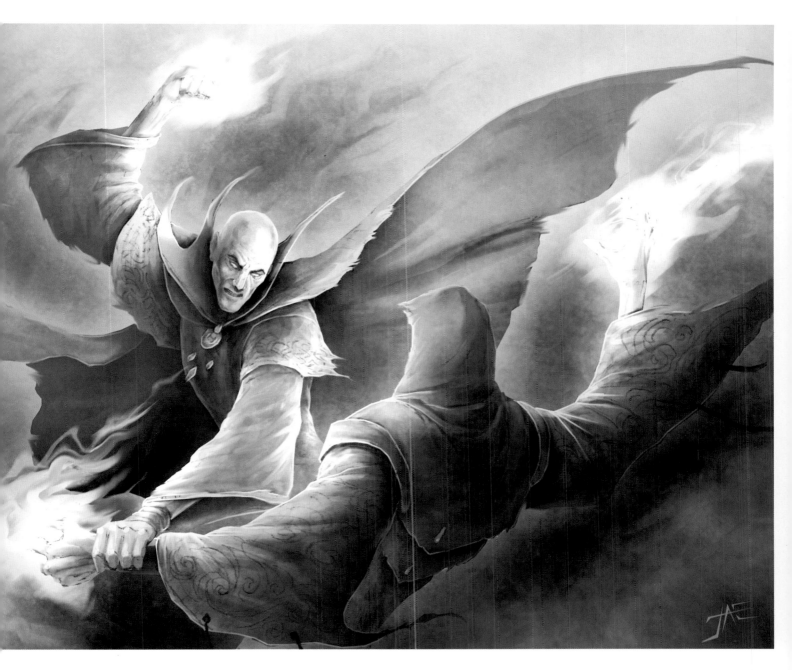

ARCANE ATTACK
2003, Digital, 7 x 5 in
AEG, Warlord CCG

Opposite: DWARVEN LORDS
2003, Digital, 21 x 5½ in
AEG, Warlord CCG

Below: DEVERENIAN LORDS
2003, Digital, 21 x 6 in
AEG, Warlord CCG

This image is part of a specific series of cards I painted for AEG's Warlord game. I was contracted to do an entire expansion set for the game, which was incredibly exciting, and the deadline limited the production time to just under a month, which made it slightly less exciting, and more of an imposing challenge. I, of course, was willing to try, even though I'd never painted at that speed before, but the prospect of success was too enticing to turn it down.

To help speed the production, I asked the art director to allow me to link many of the cards based on individual faction, and thus allow me to paint many characters in the same setting, creating several very wide images, instead of dozens and dozens of individual backgrounds. This created a very unified feel for the cards.

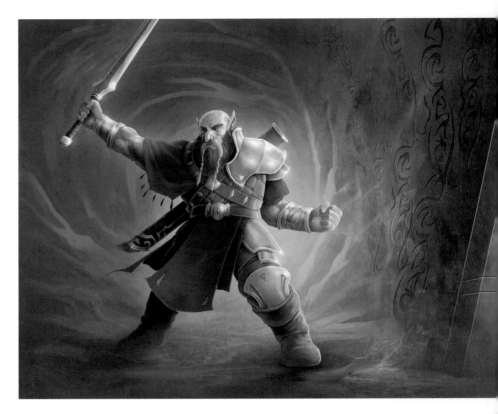

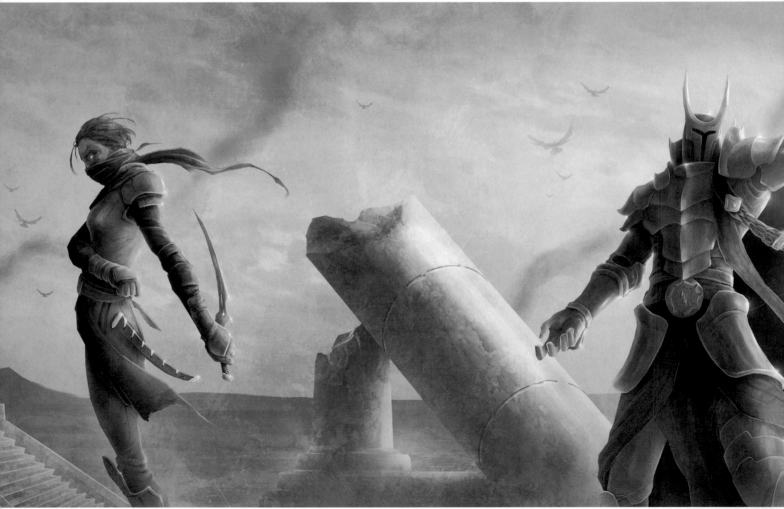

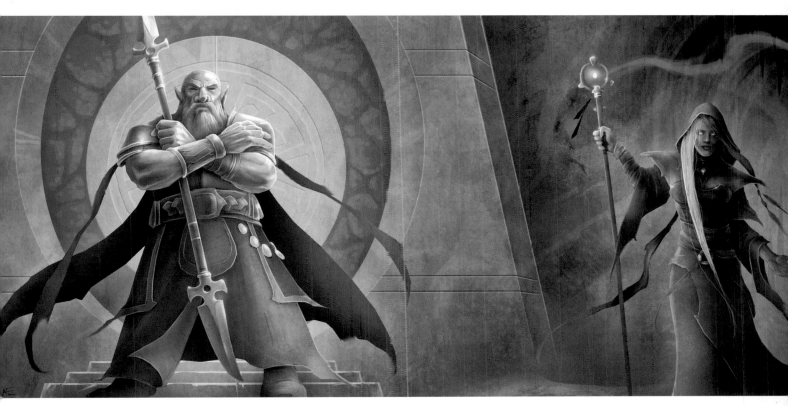

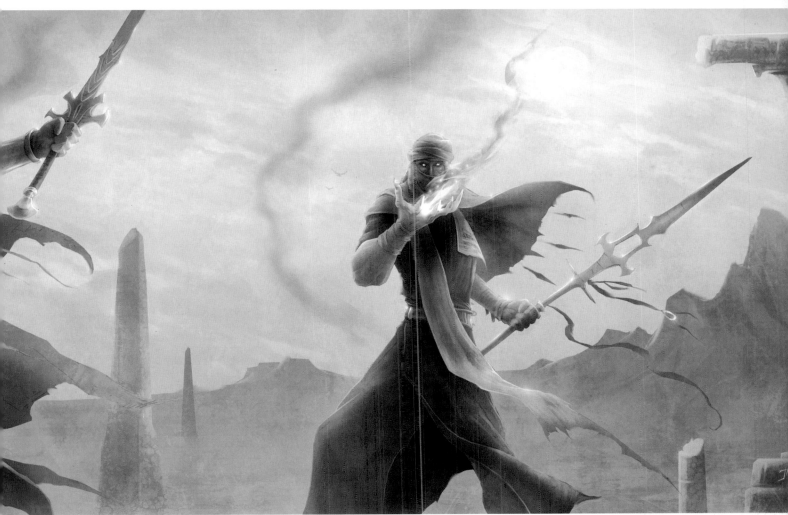

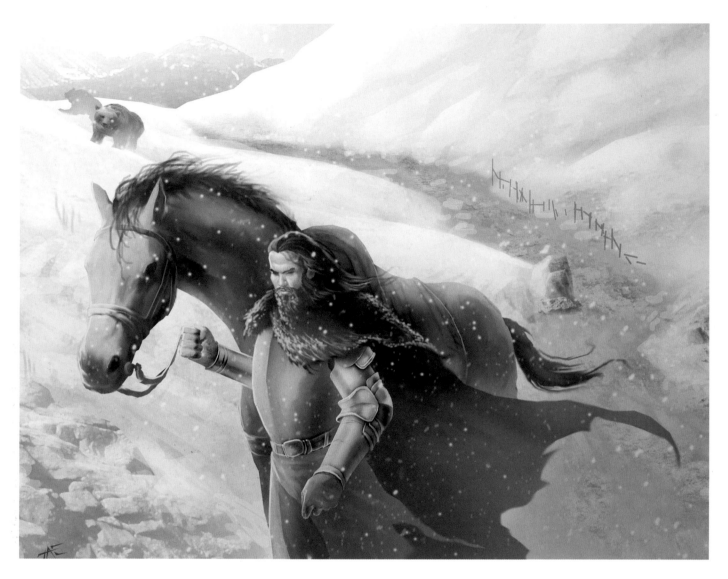

HOUSE MORMONT KNIGHT
2003, Digital, 7 x 5 in
Fantasy Flight Games, Game of Thrones CCG

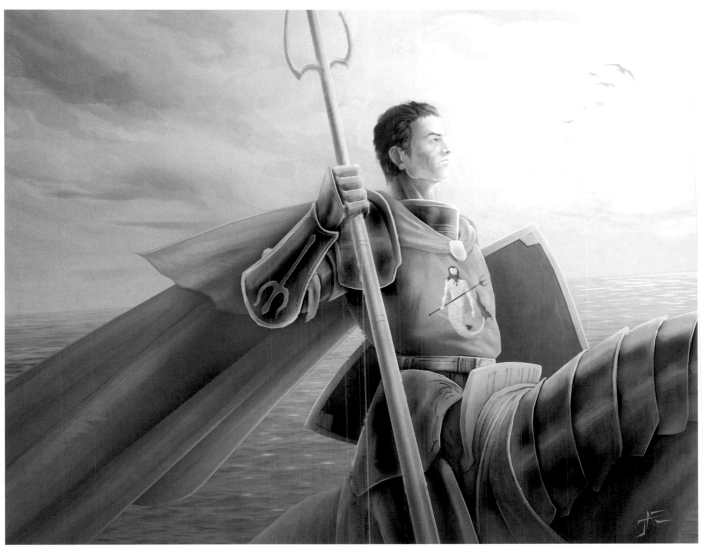

HOUSE MANDERLY KNIGHT
2003, Digital, 7 x 5 in
Fantasy Flight Games, Game of Thrones CCG

VANGUARD OF THE ROSE
2004, Digital, 7 x 5 in
Fantasy Flight Games, Game of Thrones CCG

TWO SWORDS
2002, Digital, 7 x 5½ in
AEG, Legend of the Five Rings CCG

Another commission intended to be split into multiple cards. It was meant to
depict two samurai of the Phoenix clan, with two very opposite personalities. One
is serene and thoughtful, the other is poised and ready to act at a moment's notice.
The image was eventually used for marketing materials, and was also later used in
the updated style guide for the card game.

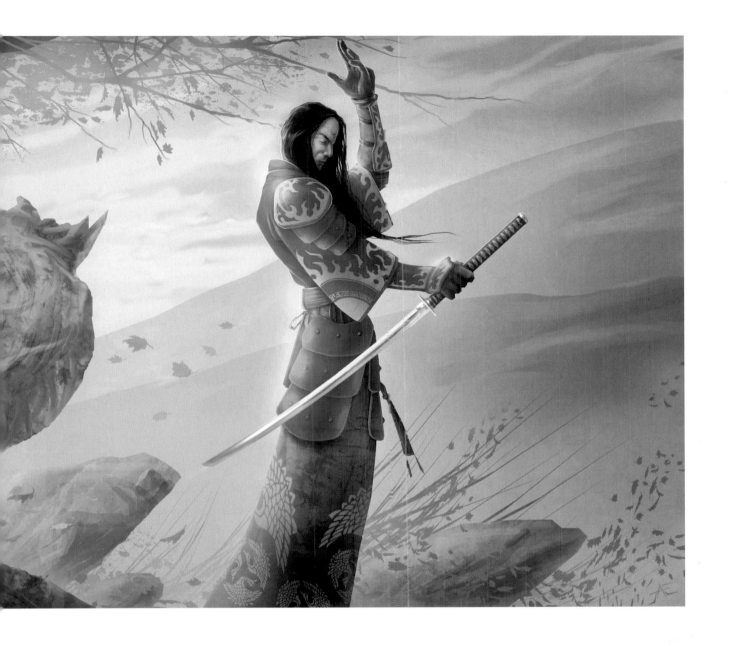

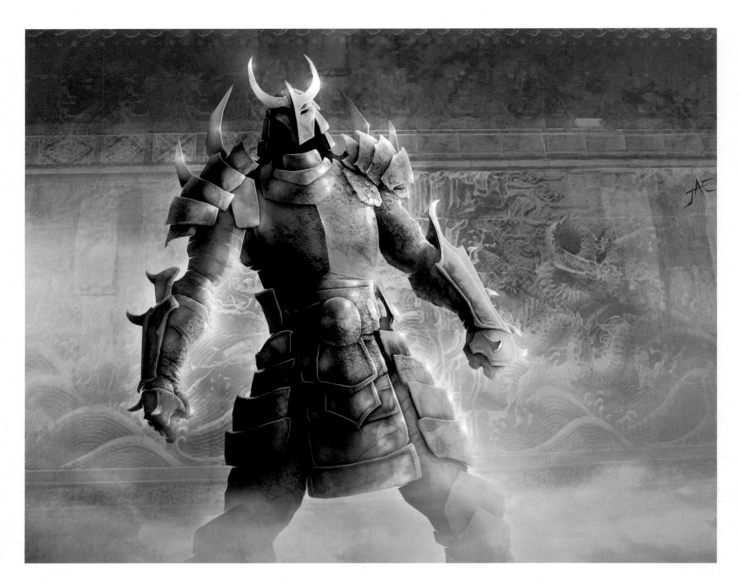

OBSIDIAN CHAMPION
2001, Digital, 7 x 5½ in
AEG, Legend of the Five Rings CCG

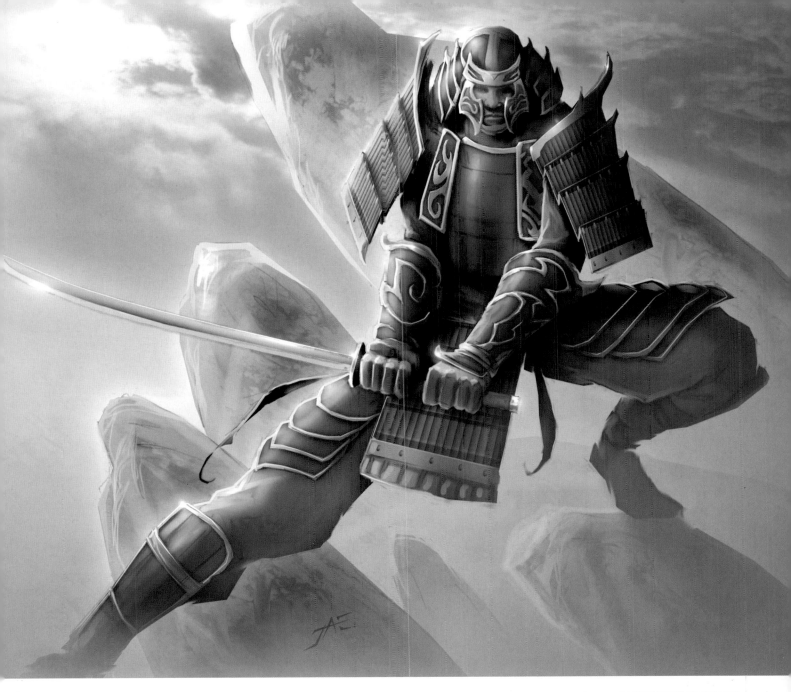

SCORPION
2002, Digital, 7 x 5 in
AEG, Warlord CCG

GHOSTBLADE
2002, Digital, 7 x 5 in
AEG, Warlord CCG

ELF LORDS
2003, Digital, 28 x 6 in
AEG, Warlord CCG

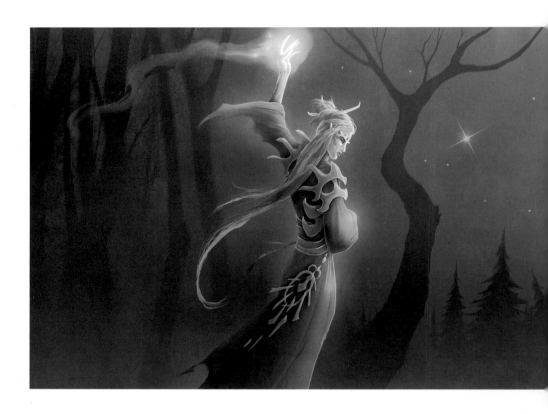

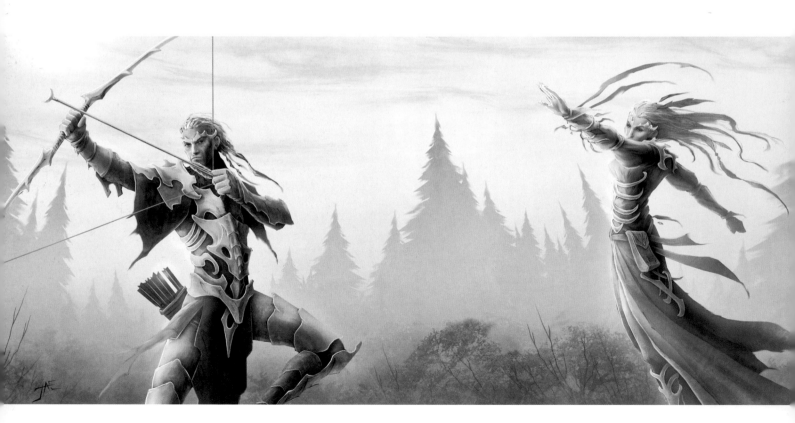

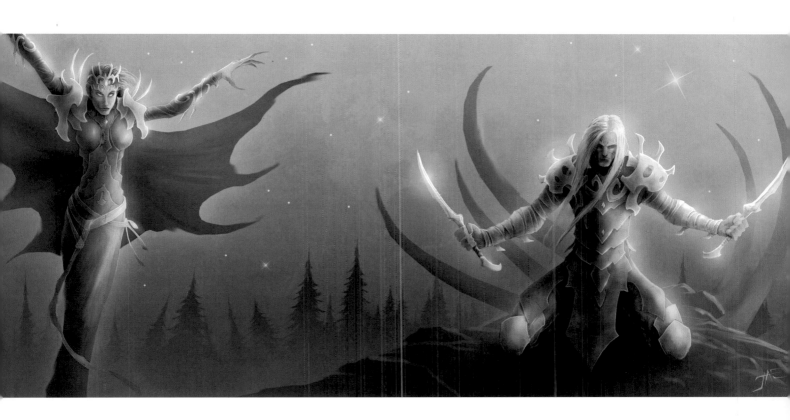

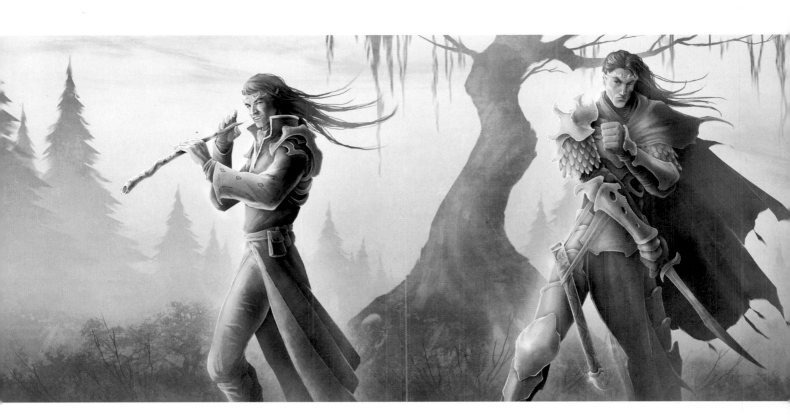

ELVES
2003, Digital, 21 x 5½ in
AEG, Warlord CCG

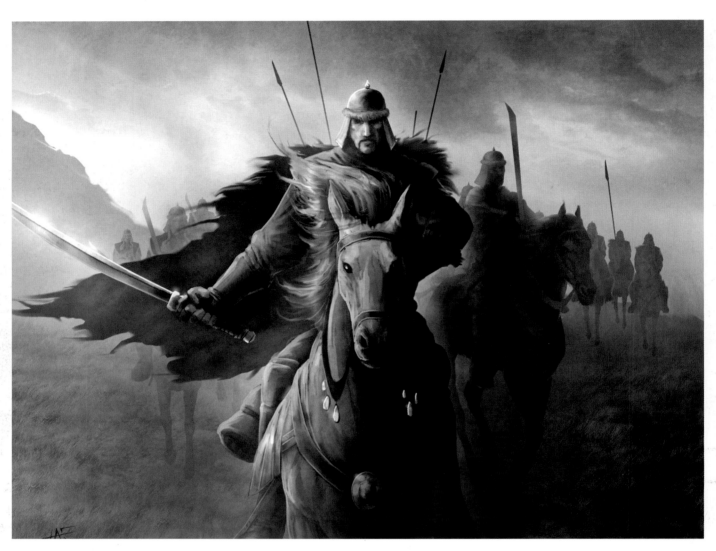

FLASHING BLADES
2004, Digital, 7 x 5 in
AEG, Legend of the Five Rings CCG

STONEBLIGHT
2001, Digital, 7 x 5 in
AEG, Warlord CCG

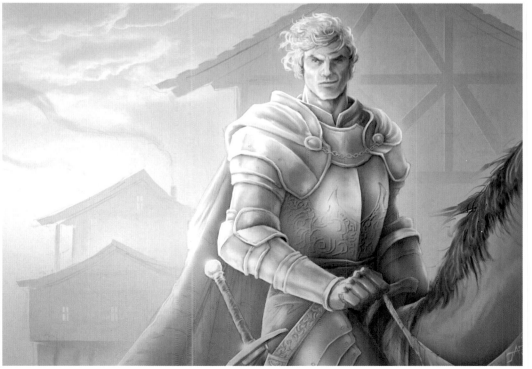

JAIME LANNISTER
2002, Digital, 7 x 5 in
Fantasy Flight Games, Game
of Thrones CCG

This is one of my favourite
characters from the Game of
Thrones books, I was thrilled to
see him included in the set of
cards I was assigned. One of the
more interesting characters in the
story, his personality and
motivations were never one-sided
or unbelievable, as most
antagonists in fantasy literature
tend to be, which made him far
more interesting to paint.

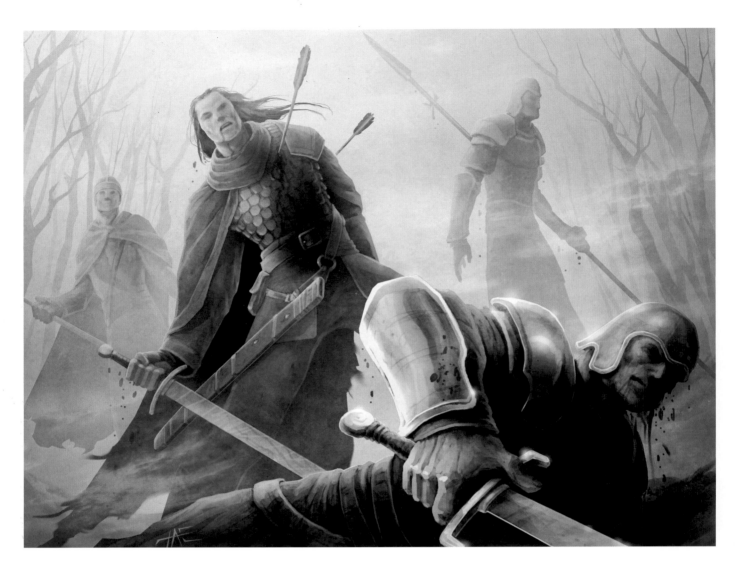

KISS OF THE RED GOD
2004, Digital, 7 x 5½ in
Fantasy Flight Games, Game of
Thrones CCG

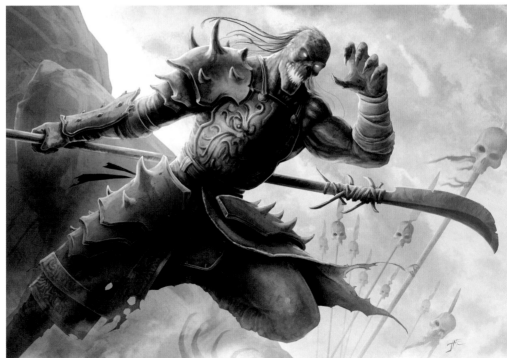

**SHADOWLANDS
BLOODSPEAKER**
2004, Digital, 7 x 5 in
AEG, Legend of the Five Rings CCG

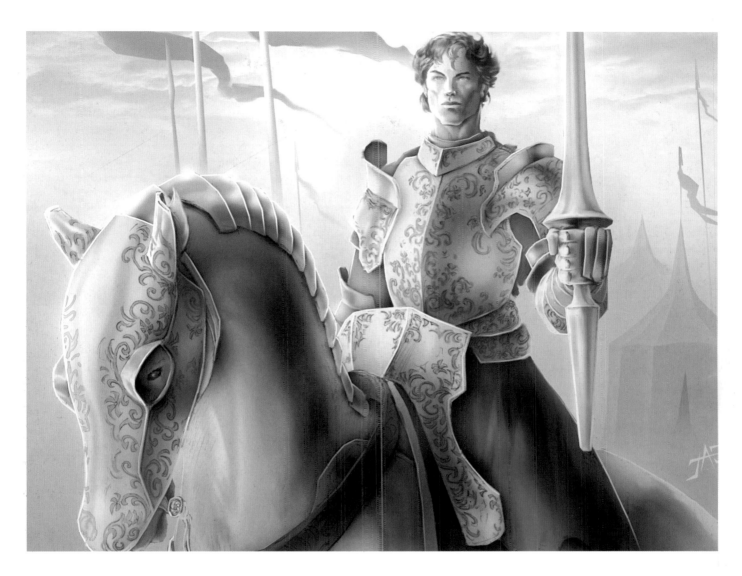

KNIGHT
2001, Digita , 8½ x 11 in
Dungeon Magazine

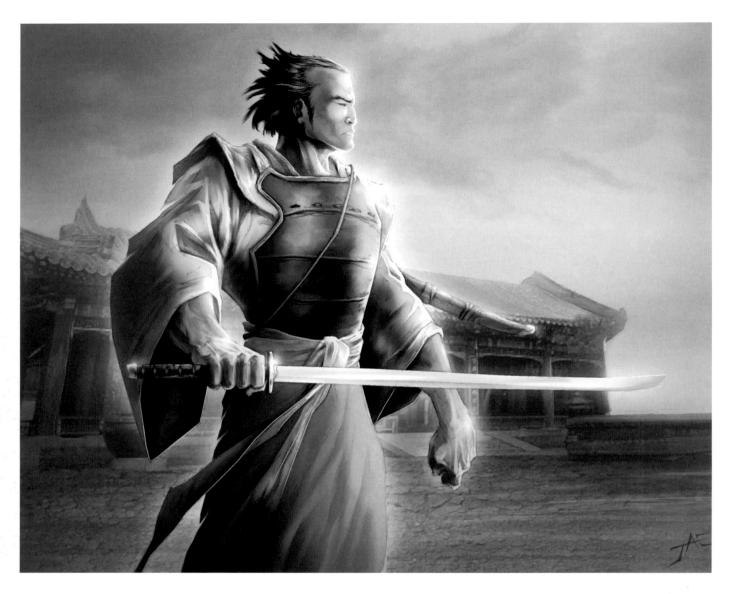

LION
2001, Digital, 7 x 5 in
AEG, Legend of the Five Rings CCG

MYSTIC SWORD
2004, Digital, 7 x 5½ in
AEG, Legend of the Five Rings CCG

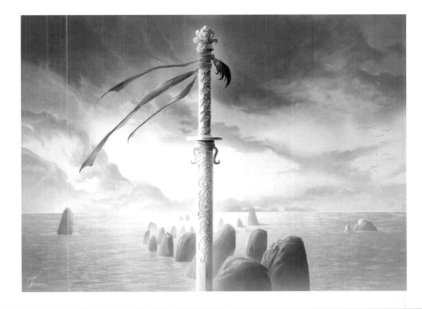

LAST MAN STANDING
2001, Digital, 7 x 5½ in
AEG, Legend of the Five Rings CCG

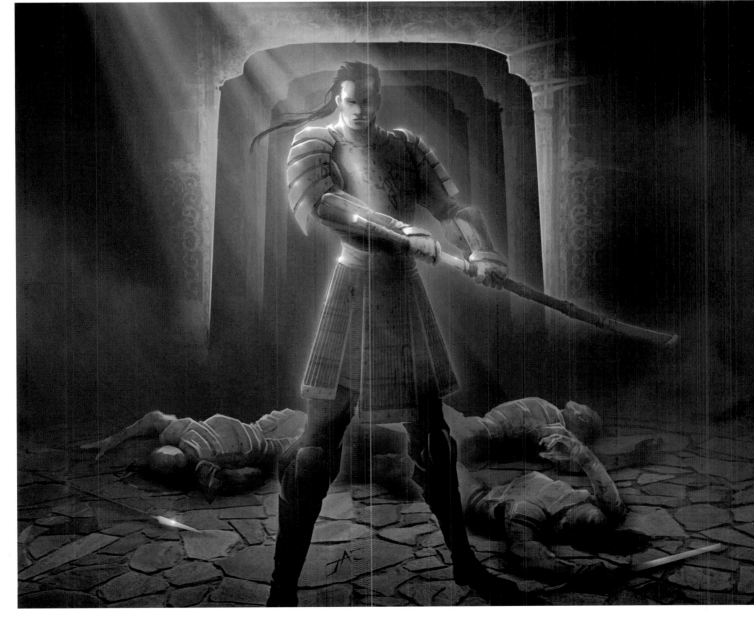

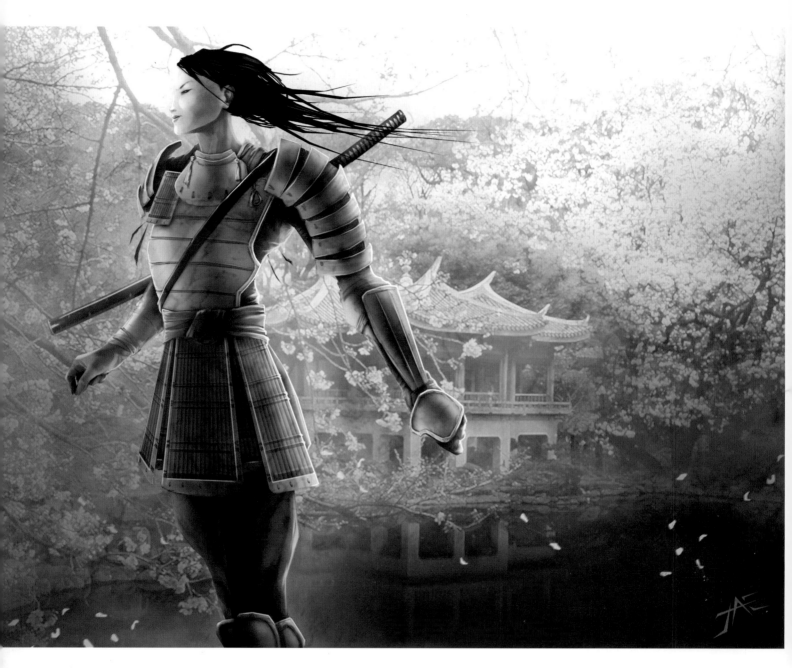

AKODO
2001, Digital, 7 x 5 in
AEG, Legend of the Five Rings CCG

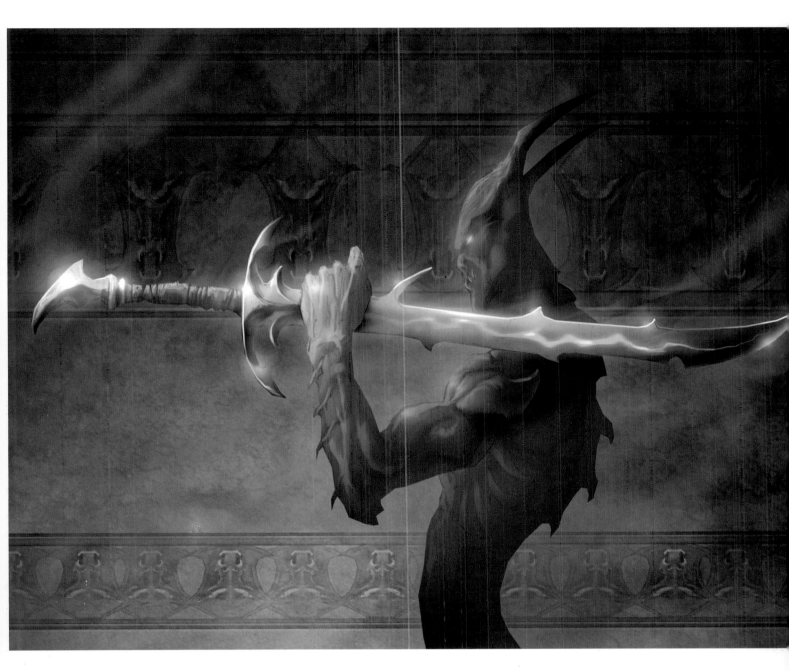

ABYSSAL BLADE
2001, Digital, 7 x 5½ in
AEG, Warlord CCG

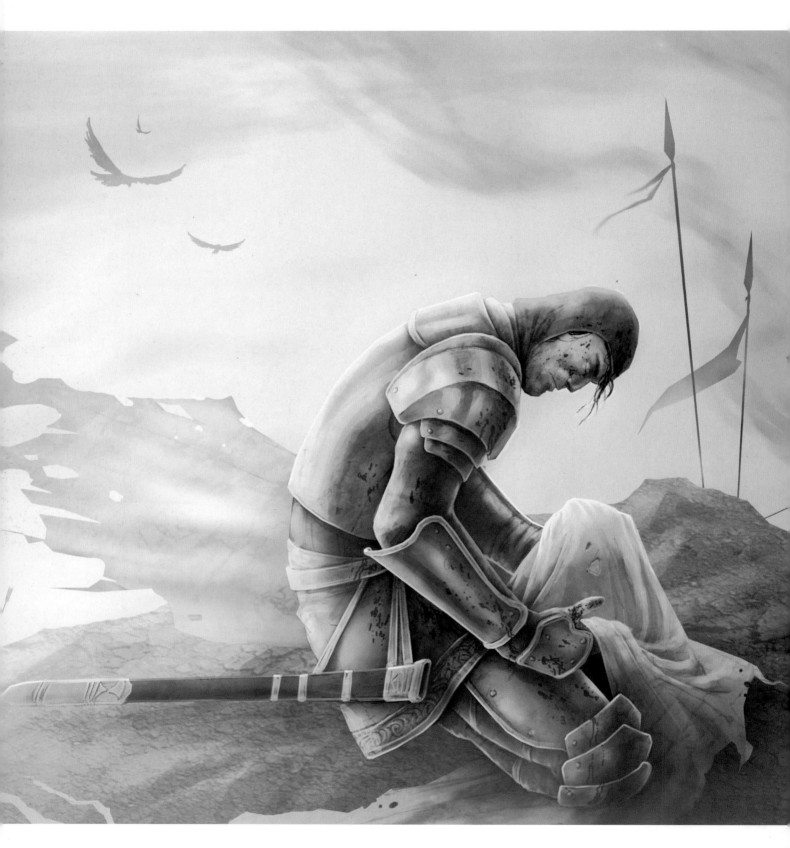

SHAME
2003, Digital, 7 x 5 in
Fantasy Flight Games, Game of Thrones CCG
AEG, Legend of the Five Rings CCG

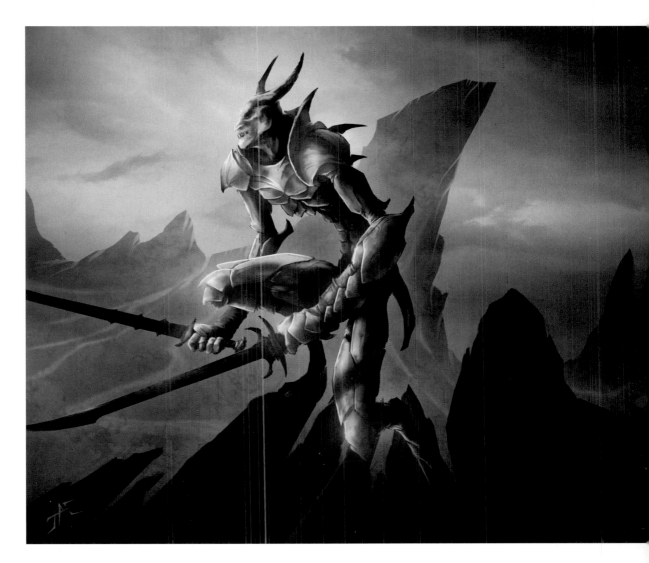

FIEND WARRIOR
2001, Digital, 7 x 5 in
AEG, Warlord CCG

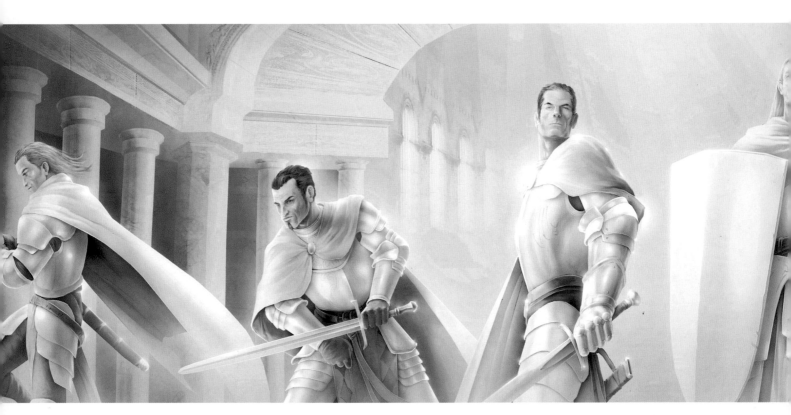

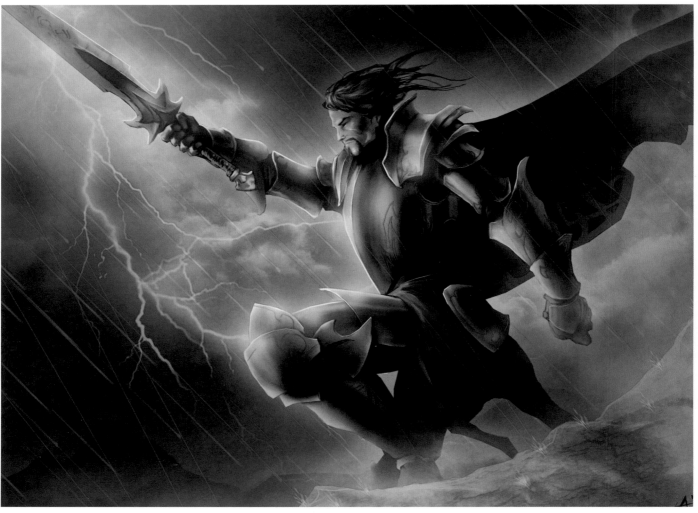

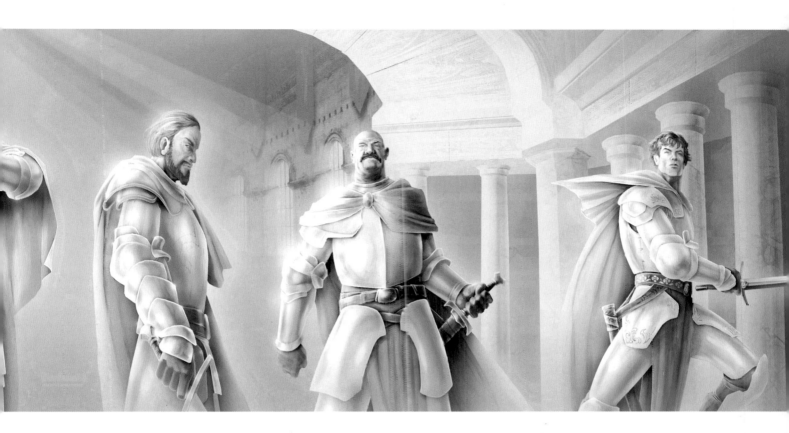

KINGSGUARD
2002. Digital, 30 x 7 in
Fantasy Flight Games, Game of Thrones CCG

This was an interesting project, as they wanted me to do all seven of the
Kingsguard, an order of elite knights and bodyguards, and they wanted them
all to be part of the same image. At the time, I had never painted a single
image intended for multiple cards, and it was quite a challenge to create a
composition that was both correct in perspective (well, sort of), and wide
enough to accommodate all seven of the characters.

STORM KNIGHT
2001, Digital, 7 x 5½ in
AEG, Warlord CCG

MANTIS
2001, Digital, 7 x 5½ in
AEG, Legend of the Five Rings CCG

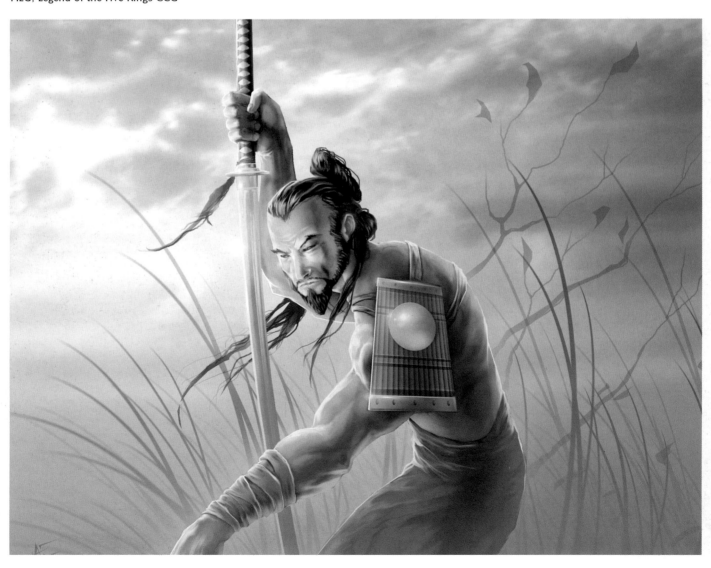

DRAGON'S BREATH
2001, Digital, 7 x 5 in
AEG, Warlord CCG

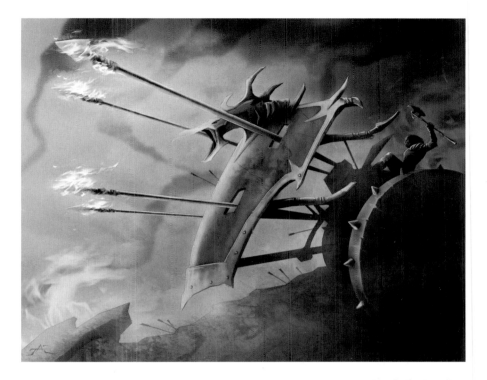

GAUNTLETS OF THE OCEAN
2001, Digital, 7 x 5 in
AEG, Warlord CCG

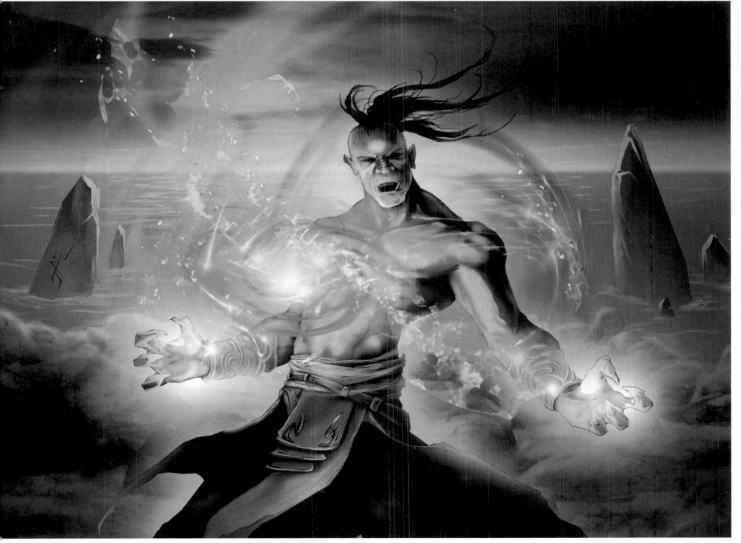

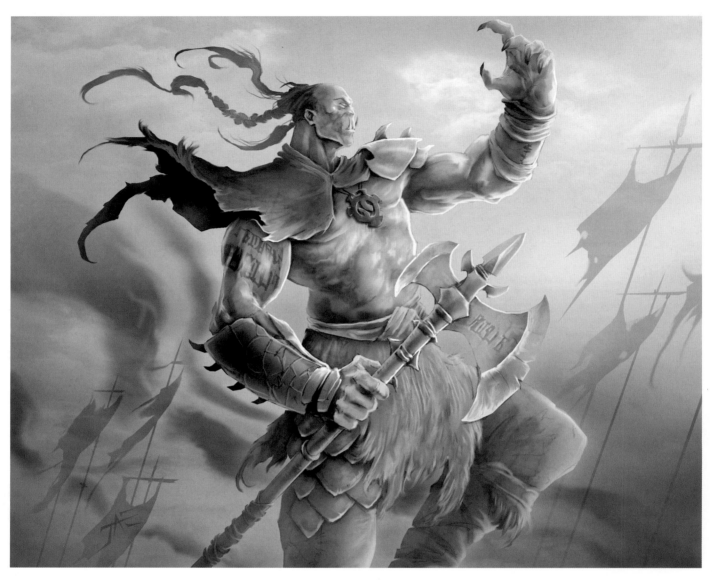

WARLORD
2001, Digital, 7 x 5½ in
AEG, Warlord CCG

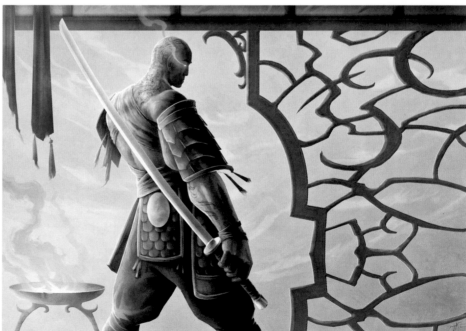

WARRIOR OF THE DRAGON
Digital, 7 x 5 in
AEG, Legend of the Five Rings CCG

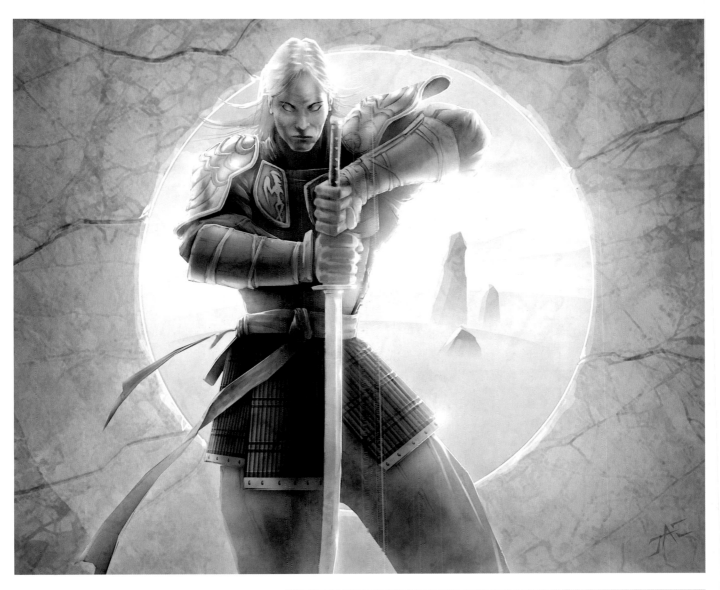

CRANE

2001, Digital, 7 x 5½ in
AEG, Legend of the Five Rings CCG

Created as one of my first cards for the L5R card game, it was also my first attempt to depict a samurai of the Crane clan, and I followed the style guide far too closely in my opinion. When I'm given a style guide with lots of visual reference to work from, I try to find and select the good and bad points, the identifying and signature elements and then use them in a way that allows for artistic licence, and a little creativity that gives the image a unique personality. But the card was later used as a marketing image for the game, so, sometimes, representing the material as closely as possible can be a good thing.

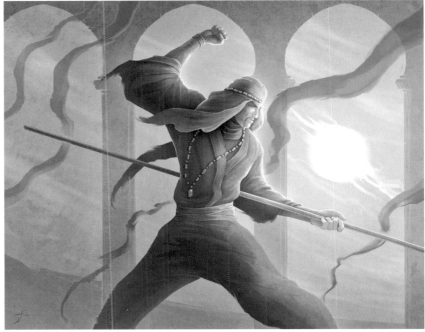

NUNZIO

2003, Digital, 7 x 5½ in
AEG, Warlord CCG

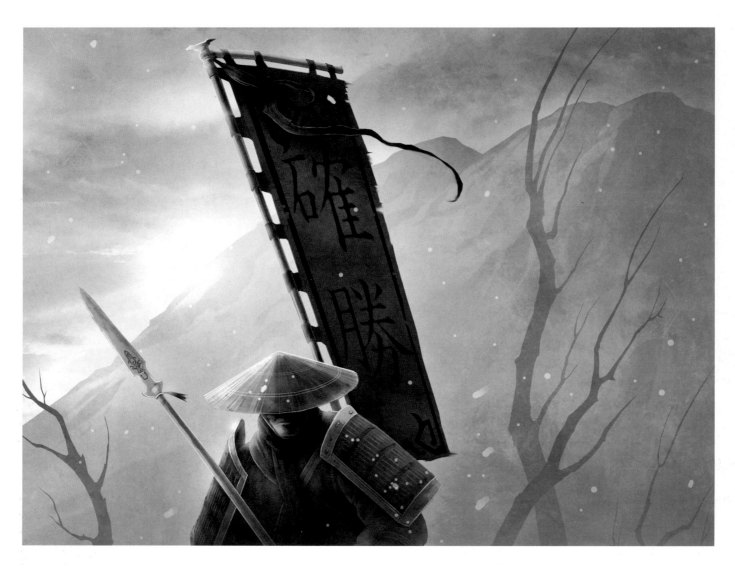

BANNER OF GLORY
2004, Digital, 7 x 5 in
AEG, Legend of the Five Rings CCG

QUEEN'S ASSASSIN
2004, Digital, 7 x 5½ in
Fantasy Flight Games, Game of Thrones CCG

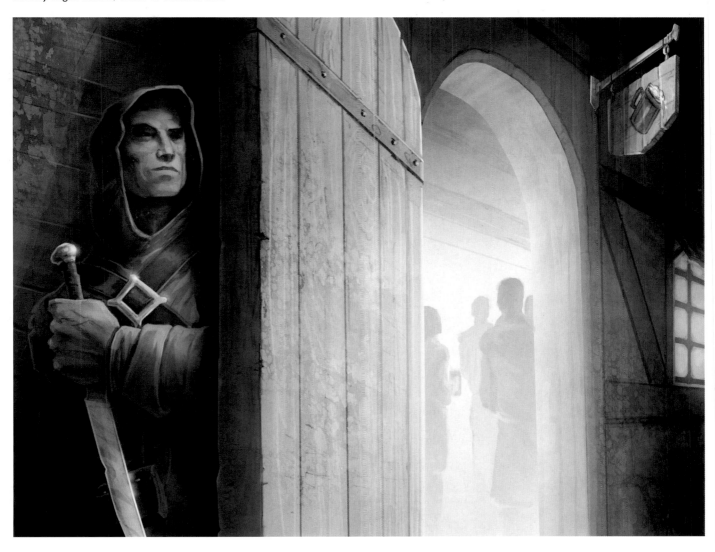

GRYPHON
2001, Digital, 7 x 5 in
AEG, Warlord CCG

I have always loved Gryphons (or griffins if you prefer) and I never pass up a chance to paint them. Although they don't come into fantasy illustration nearly as much as dragons, they still retain a lot of the essence of fantasy illustration for me. They are powerful, elegant, and combine elements of the fantastic into something wholly unique and powerful. This was one of the first cards I painted for Warlord, and appeared on the packaging for the booster packs of its expansion set.

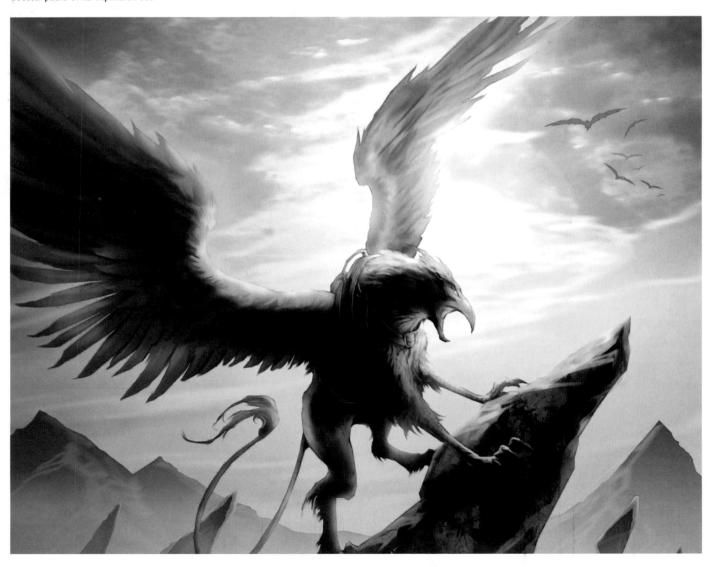

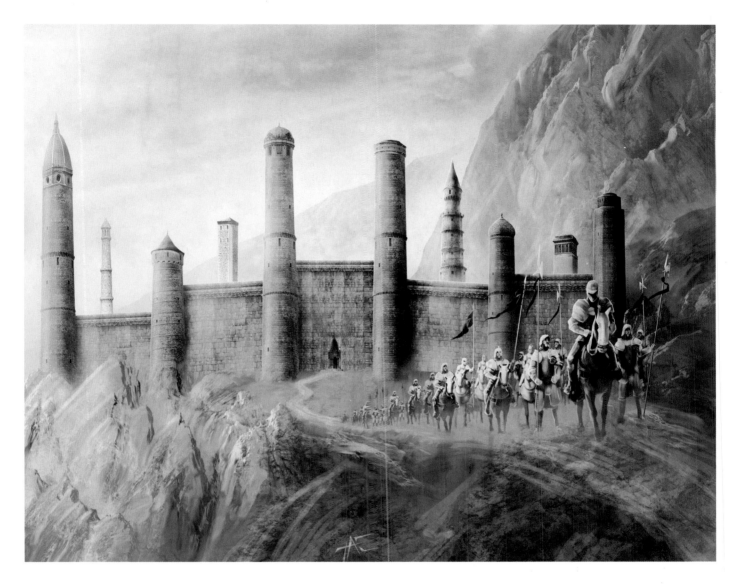

HOST OF TEN TOWERS
2003, Digital, 7 x 5 in
Fantasy Flight Games, Game of Thrones CCG

NAMELESS HERO
2003, Digital, 7 x 5 in
Fleer, Ophidian CCG

DEATH FROM ABOVE
2004, Digital, 7 x 5½ in
AEG, Legend of the Five Rings CCG

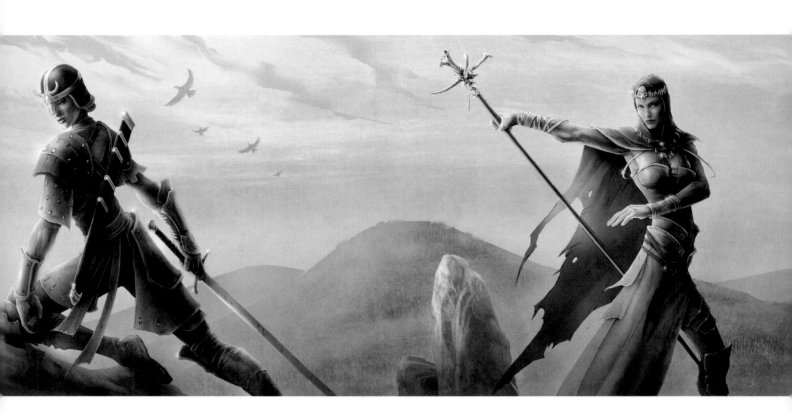

FREE KINGDOMS
2003, Digital, 21 x 5½ in
AEG, Warlord CCG

CALL OF BATTLE
2002, Digital, 7 x 5 in
AEG, Warlord CCG

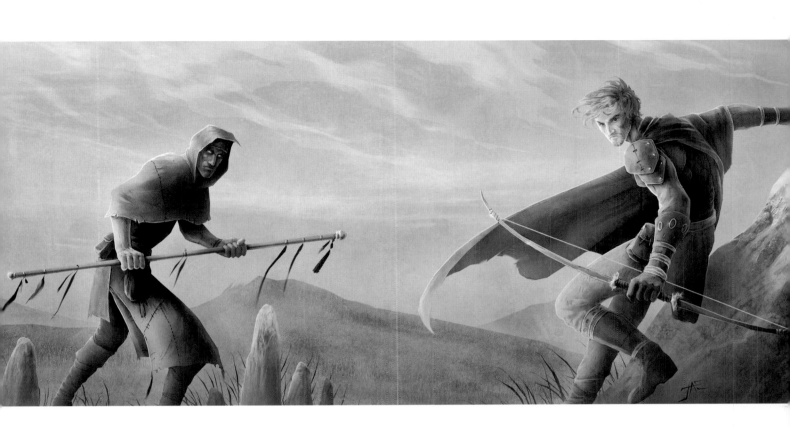

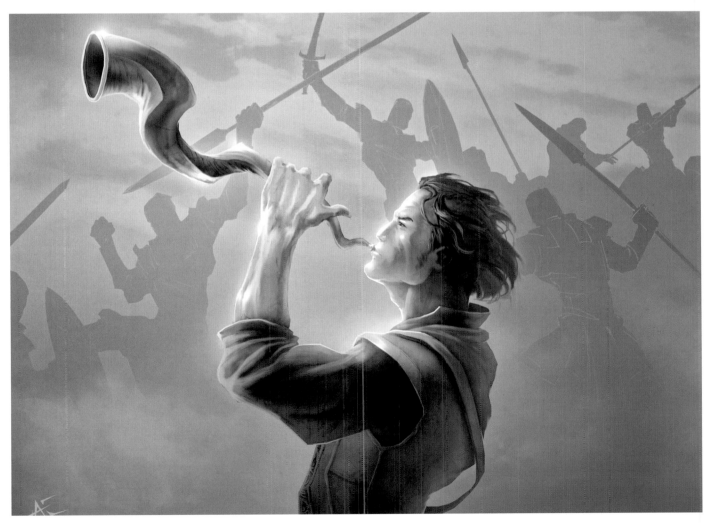

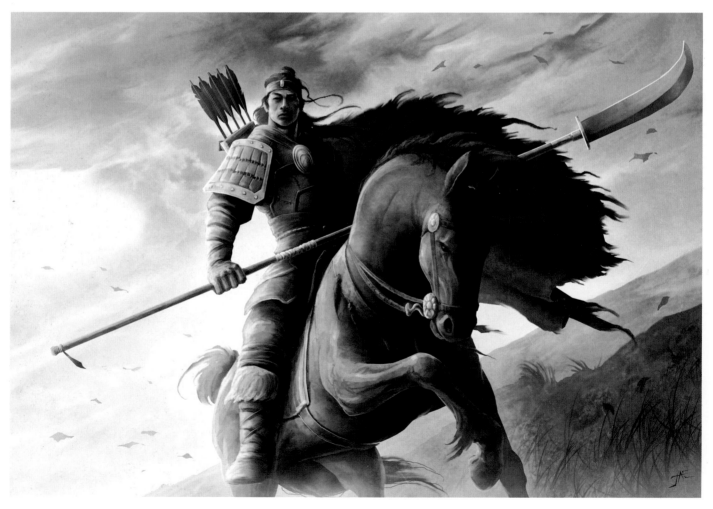

HERO
2004, Digital, 7 x 5 in
AEG, Legend of the Five Rings CCG

CLERICS HAMMER
2003, Digital, 7 x 5 in
AEG, Warlord CCG

Below: **DEMON SLAYER**
2002, Digital, 7 x 5 in
AEG, Warlord CCG

DUELIST
2003, Digital, 7 x 5 in
AEG, Legend of the Five Rings CCG

FREE KINGDOMS LORDS
2003, Digital, 28 x 6 in
AEG, Warlord CCG

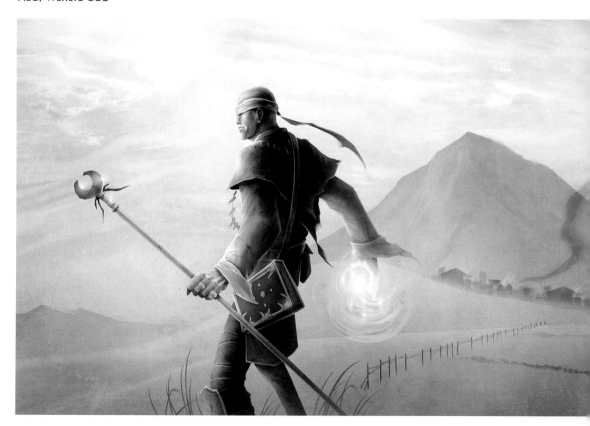

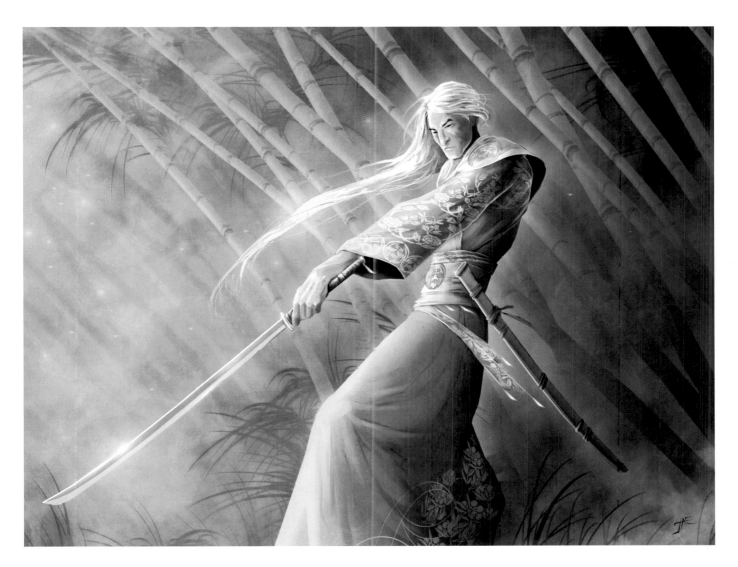

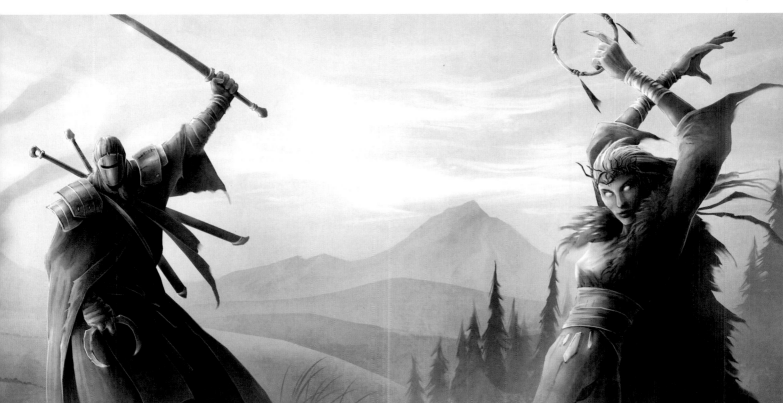

SOUL OF THE GRAND MASTER
2002, Digital, 7 x 5½ in
AEG, Legend of the Five Rings CCG

STAND AT READINESS
2003, Digital, 7 x 5½ in
Fantasy Flight Games, Game of Thrones CCG

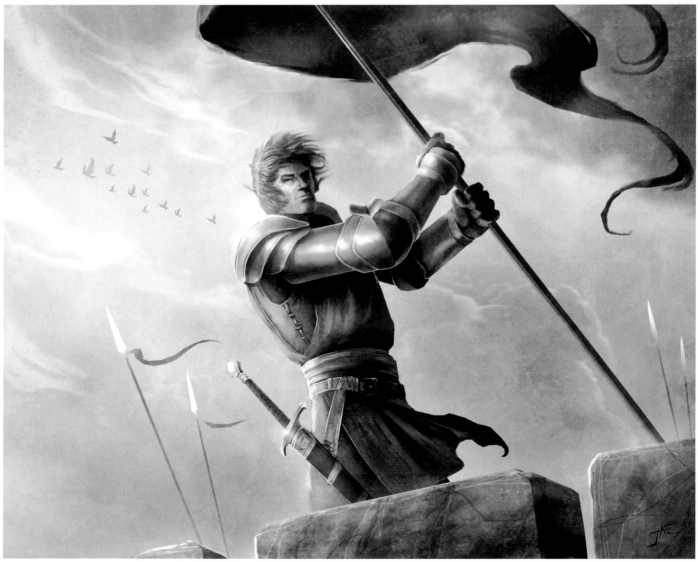

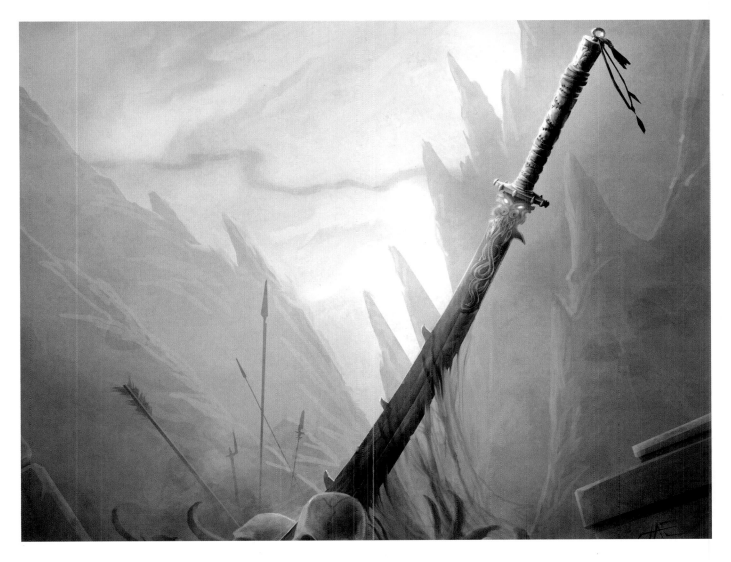

BLOODSWORD
2004, Digital, 7 x 5 in
ÆG, Legend of the Five Rings CCG

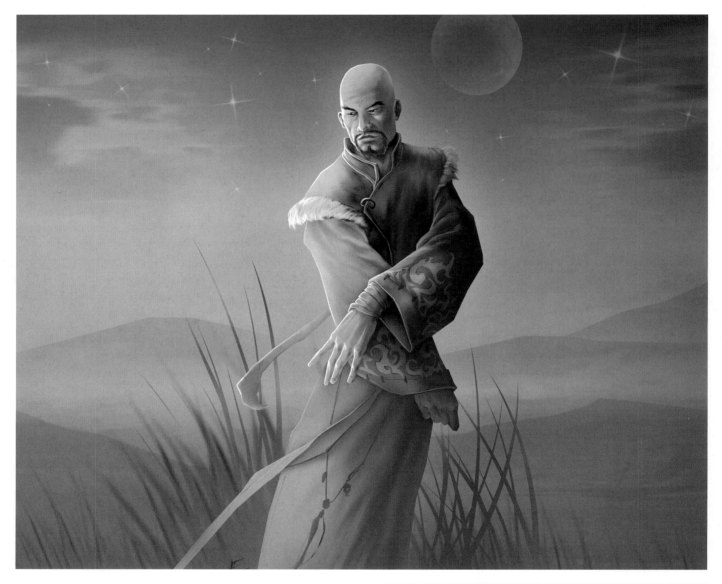

SHUGENJA

2002, Digital, 7 x 5½ in
AEG, Legend of the Five Rings CCG

This is one of my favourite L5R cards that I've
done. When it began it was something of an
experiment that simply turned out better than I had
expected. I think the simplistic composition lends
itself well to the subject matter, and helps maintain
a certain appropriate serenity to the image and its
central character.

ASAKO TAKAGI

2004, Digital, 7 x 5 in
AEG, Legend of the Five Rings CCG

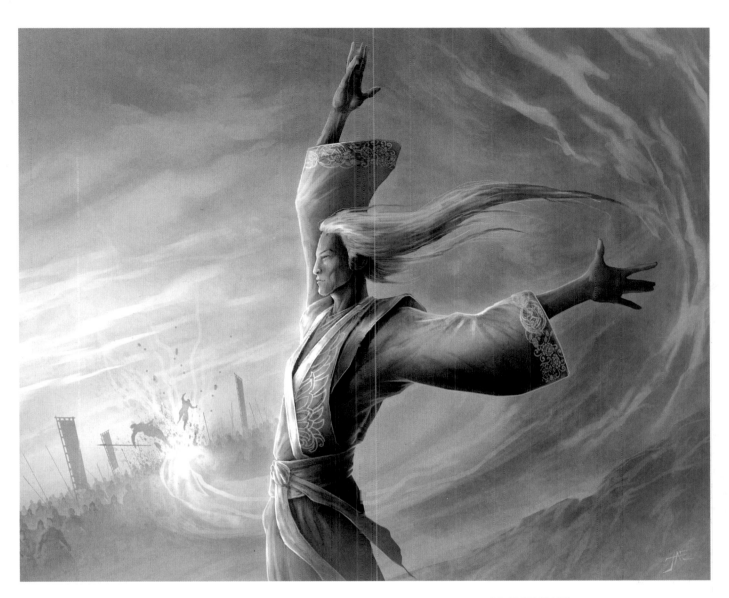

PROVIDENCE
2004, Digital, 7 x 5½ in
AEG, Legend of the Five Rings CCG

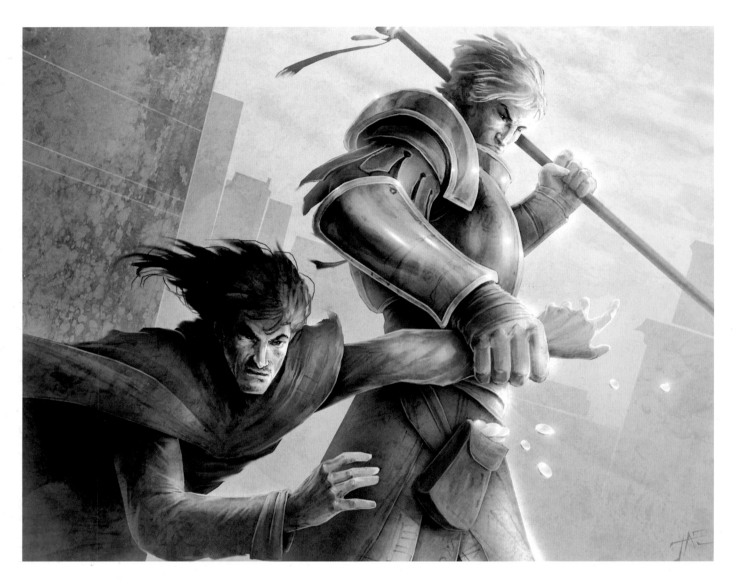

ILL-GOTTEN GAINS
2003, Digital, 7 x 5 in
AEG, Warlord CCG

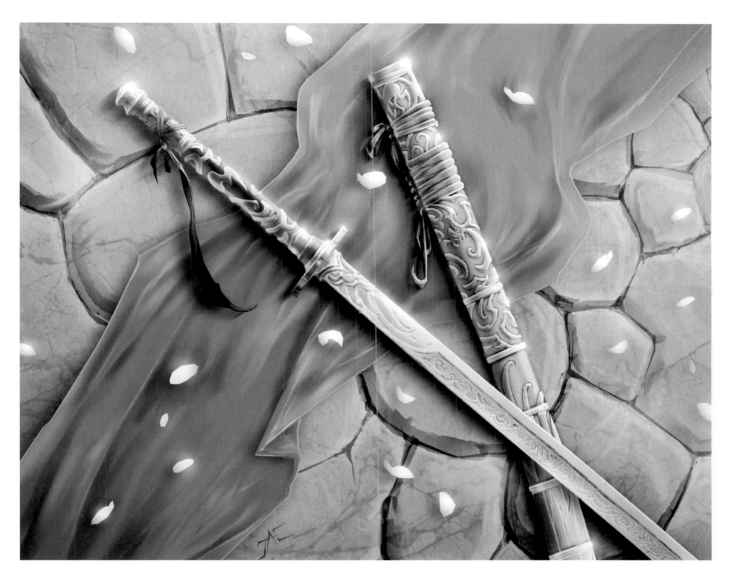

BLESSED SWORD
2002, Digital, 7 x 5 in
AEG, Legend of the Five Rings CCG

This was another image with which I was very pleased with the
outcome even though it had started out rather poorly. I was simply
tired of trying to add in too much to the environment, to give
some interest to the image without taking away from the central
focus, namely the sword itself. At some point, I decided to fold
some cloth behind the sword, and sprinkle on some cherry
blossoms for a little motion. Both ideas are certainly a bit cliché,
but worked far better than I had expected. Sometimes, the simplest
answer is really the best.

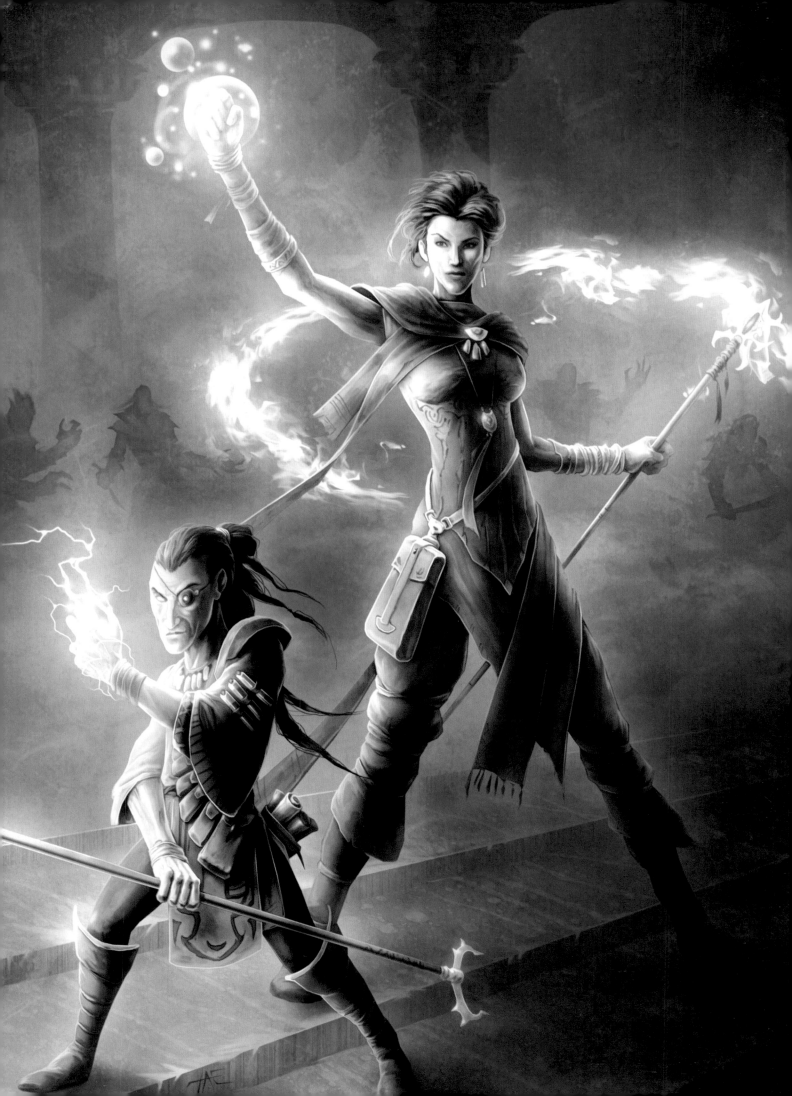

MAGAZINES

Hobby magazines are a great opportunity to illustrate many different genres and ideas that reflect the entertainment industry as a whole. The articles and features are often about the games and products that make up the lifeblood of the business, and each new month brings fresh opportunities to explore the genres of fantasy and science fiction art, while relating to the newest and hottest properties.

Facing page: MAGECRAFT
2003, Digital, 8.5 x 11 in
Dragon Magazine

ANCESTORS
2001, Digital, 8½ x 5 in
Interior for Dragon Magazine

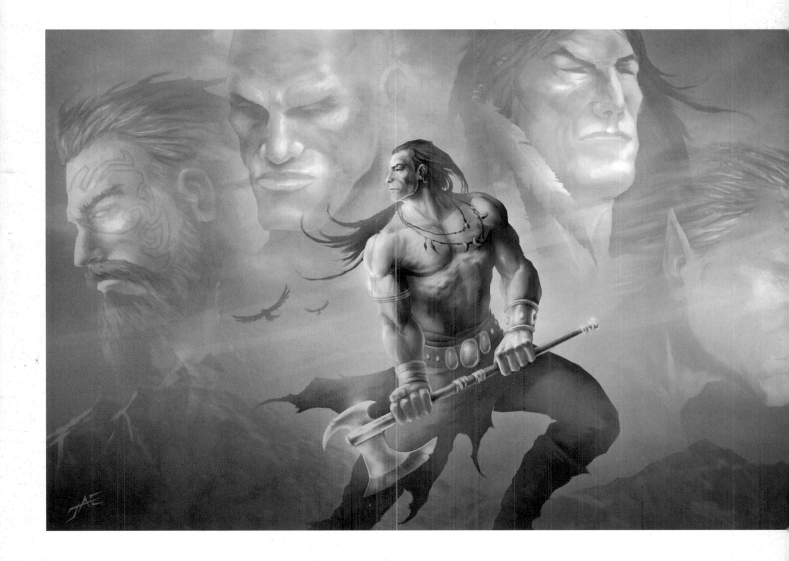

TYRANT
2002, Digital, 6½ x 5 in
Dragon Magazine

VOYAGE
2002, Digital, 8½ x 11 in
D20 Gaming Frontiers, cover

This was an unusual piece. Usually, an
Art Director commissions an image, and
provides me with subsequent descriptions
and requirements. This was not one of
those times. It was intended for the cover
of the preview edition of Gaming Frontiers
magazine, which includes content relating
to all genres of gaming. So I submitted
several very different sketch concepts,
even combining genres to keep the
magazine from looking too focused on
any one game or license. In the end, the
client decided on the only image I
submitted that was purely fantasy. I was
rather pleased that they chose this image
for the cover, as I had actually had the
sketch in my sketchbook for some time,
and had been looking for an excuse to
paint it.

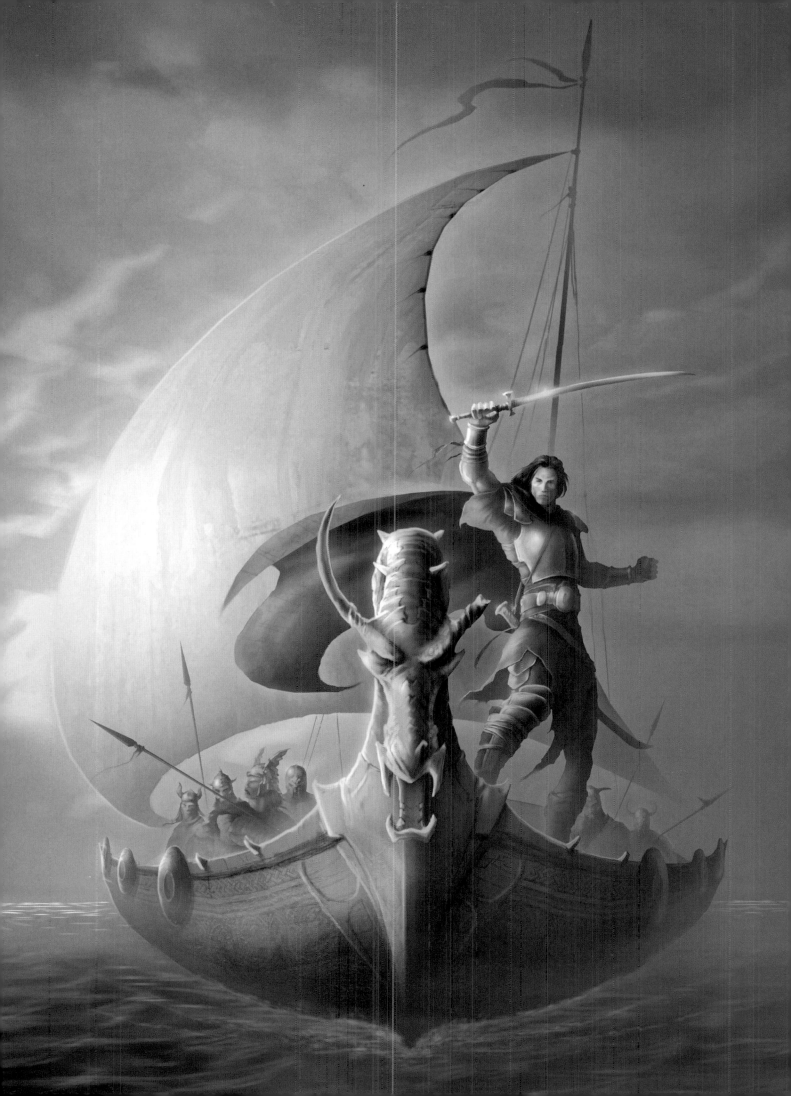

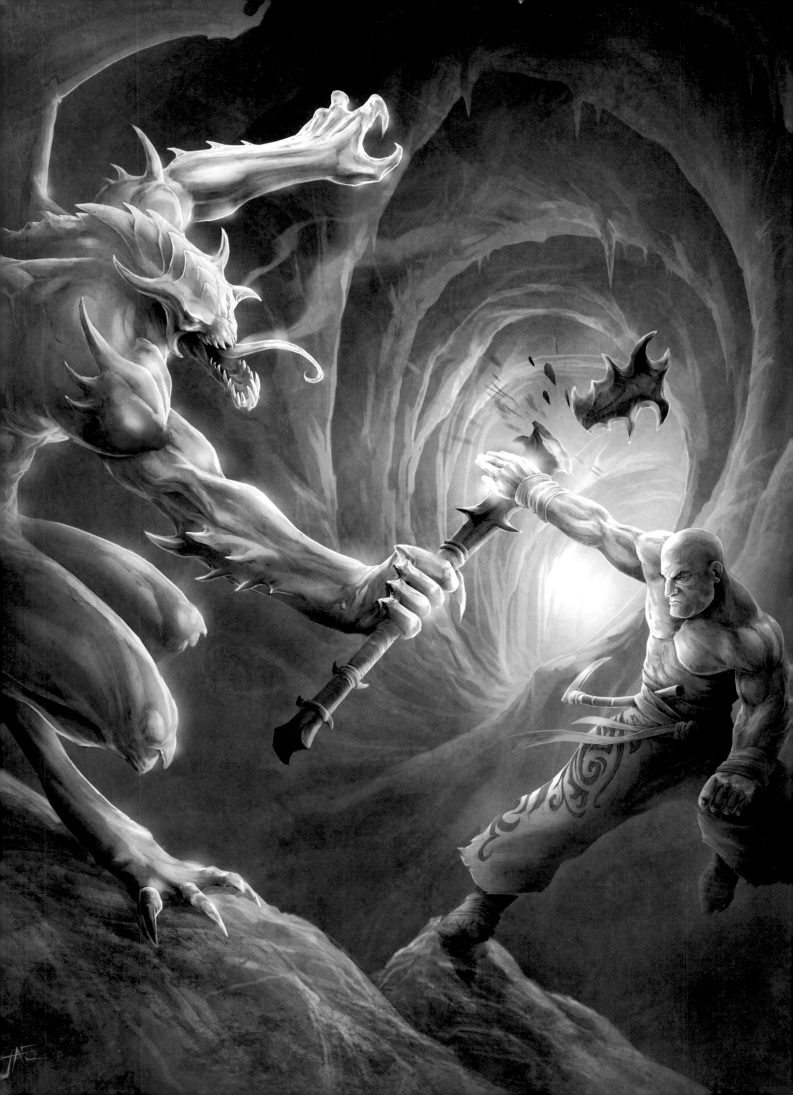

CONFRONTATION
2003, Digital, 8½ x 11 in
Dragon Magazine

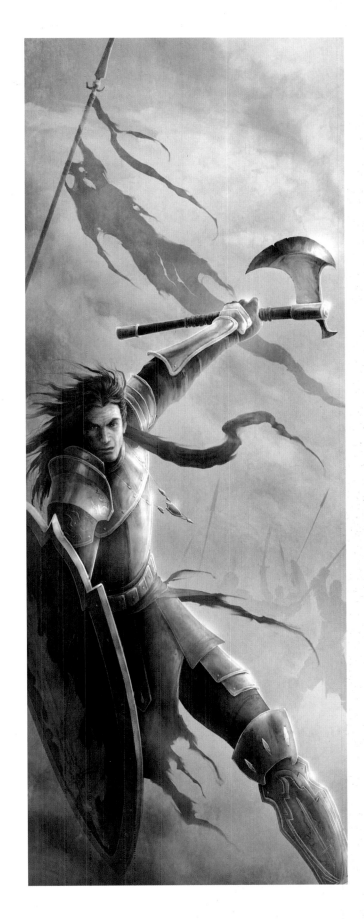

BATTLEGUARD
2003, Digital, 11¼ x 4¼ in
Interior for Dragon Magazine

BARBARIAN
2001, Digital, 4 x 8 in
Dungeon Magazine

Facing page: PALADINS
2003, Digital, 8½ x 11 in
Dragon Magazine

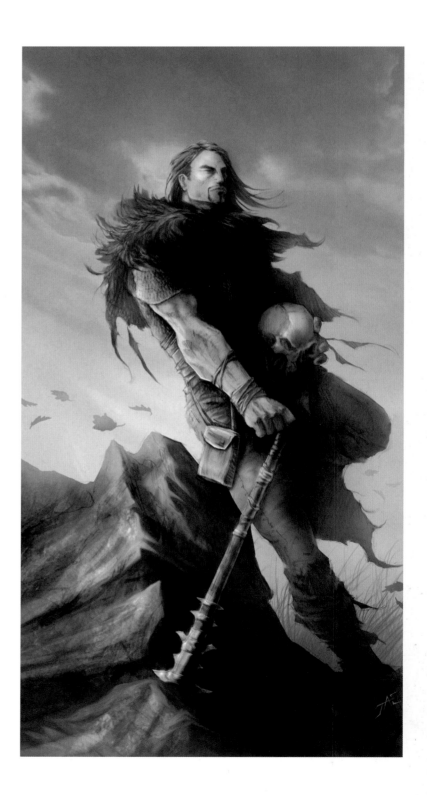

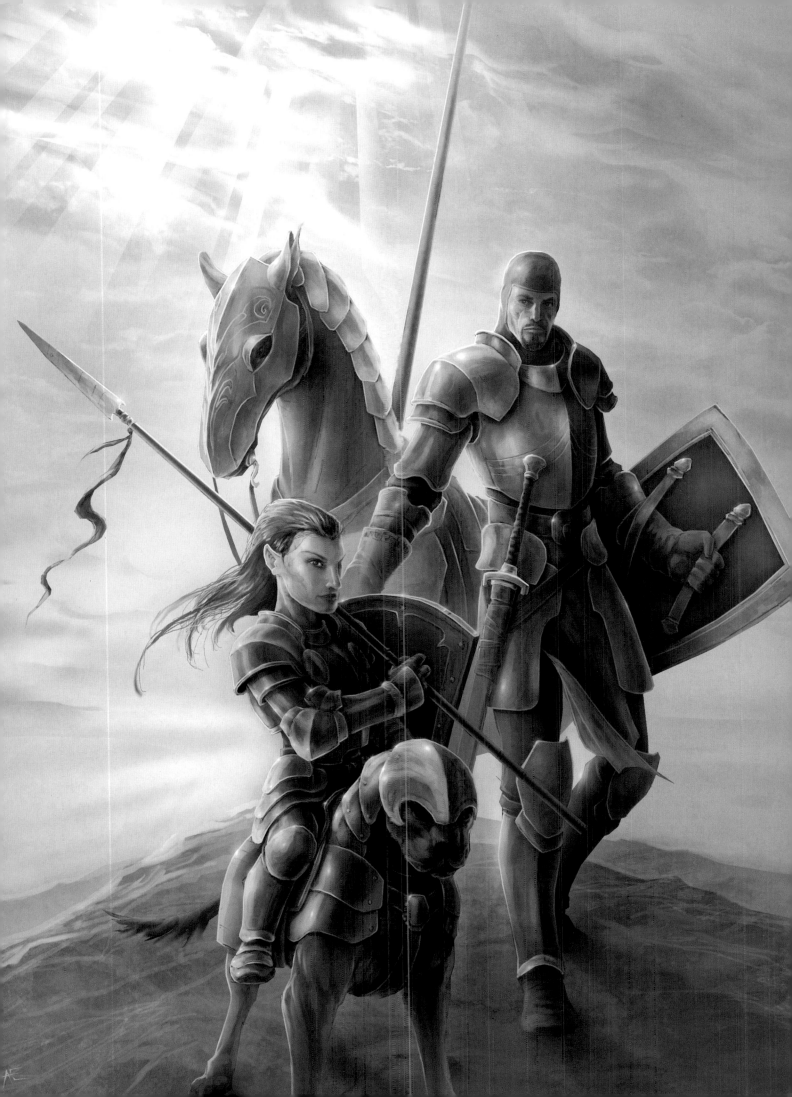

BLACK DEATH
2003, Digital, 8½ x 5 in
Interior for Dragon Magazine

This image was an unusual job for Dragon Magazine. The art director called and asked me to do an image of a Dragon, with a composition that would work as a cover image. But the catch was, she was having another artist do the same thing, and whichever painting came out better, would get on the cover of that month's issue. I did end up losing the cover to the other artist, but it's still an image I'm immensely proud of.

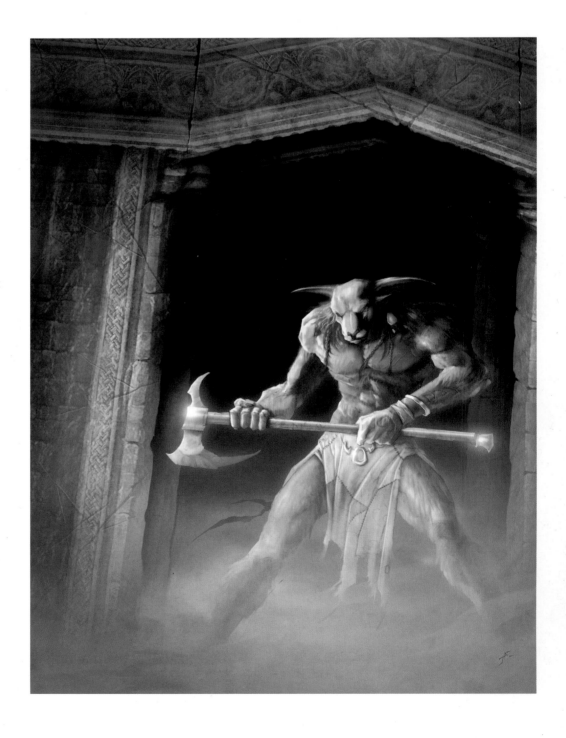

GUARDIAN
2001, Digital, 8½ x 11 in
Dungeon Magazine, Cover

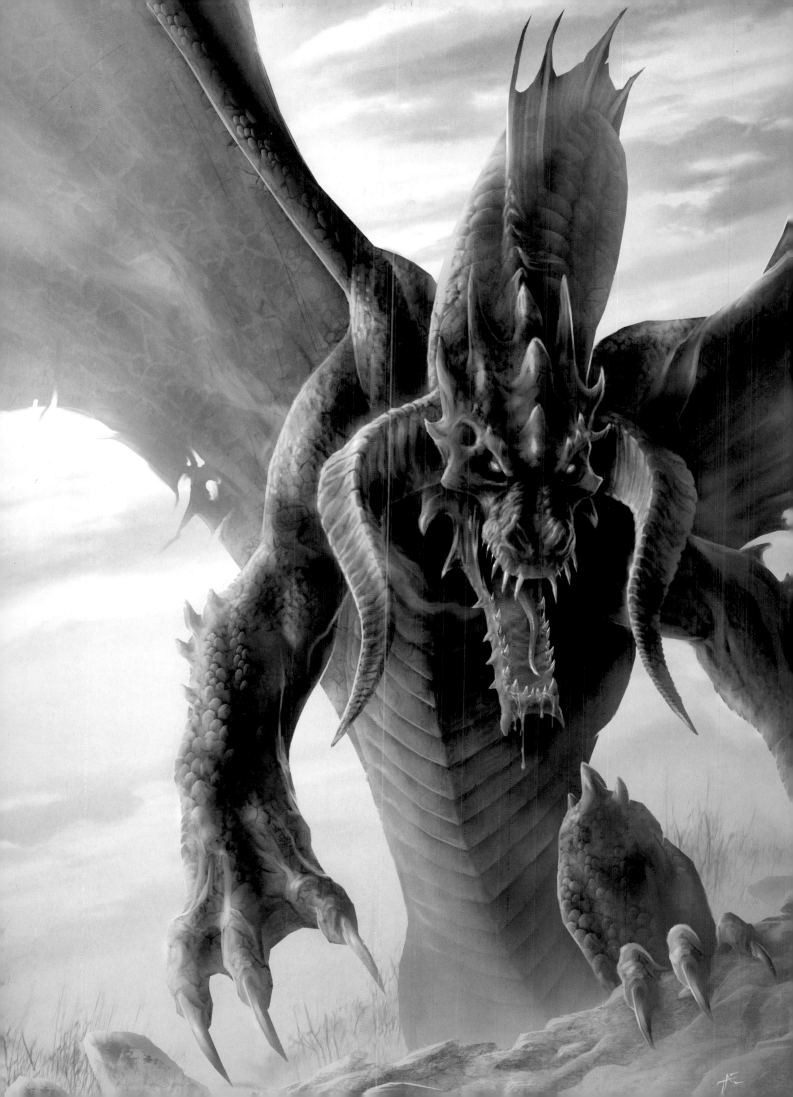

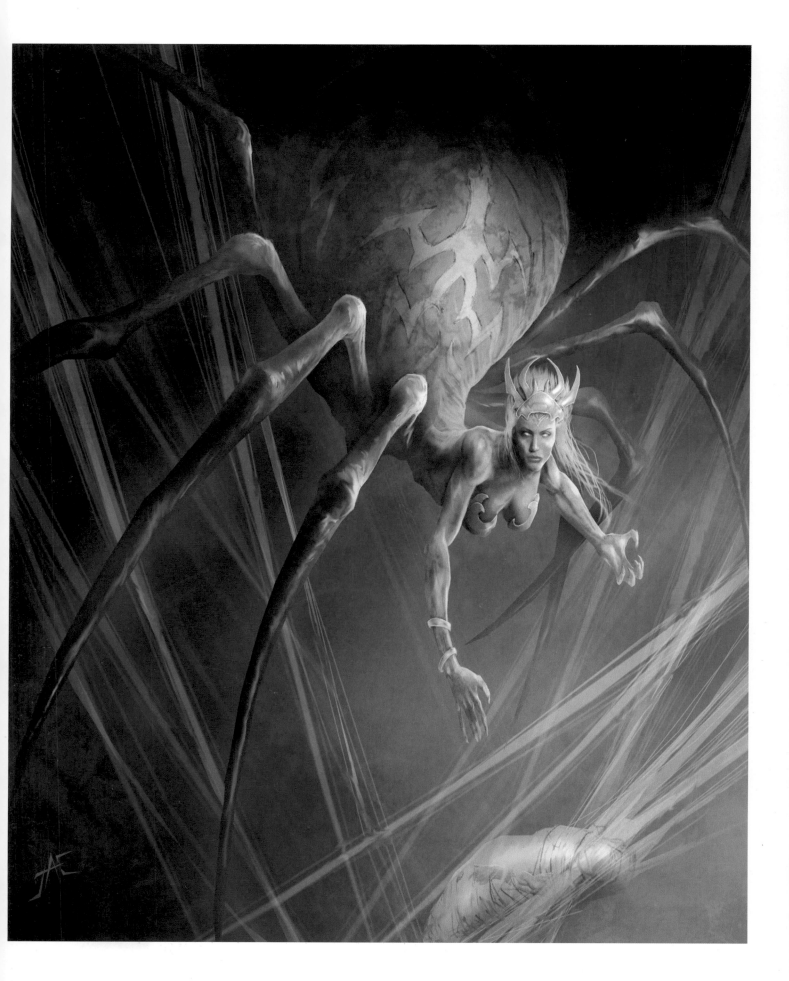

Facing page: DRIDER
2002, Digital, 4½ x 5 in
Dungeon Magazine

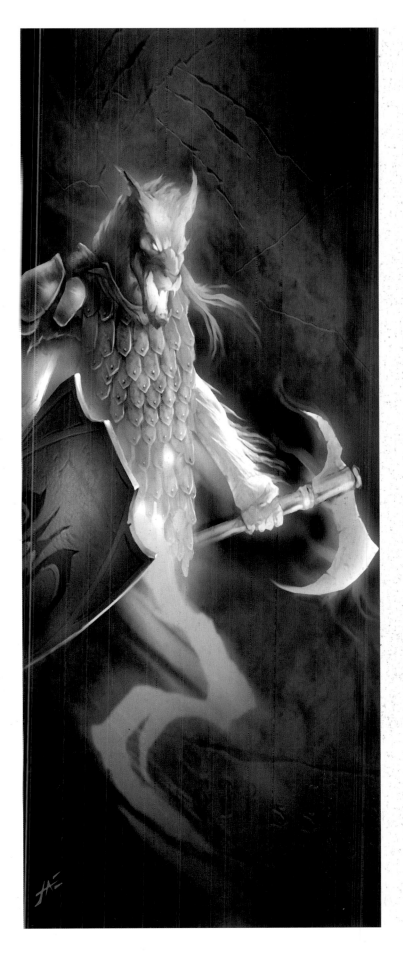

BETRAYER
2000, Digital, 4 x 8 in
Dungeon Magazine

JUSTICE
2001, Digital, 8½ x 11 in
Dragon Magazine, Cover

On a Friday, I received a call from the art
director for Dragon Magazine. I had not
yet done any work for Dragon, but was a
regular contributor to Dungeon
Magazine, their sister publication.
Apparently they had been left with a half-
finished cover image, and were in need of
a new cover fast. I had a reputation for
speed, and so the art director for
Dungeon gave them my name and over
the weekend I produced this image for
their cover.

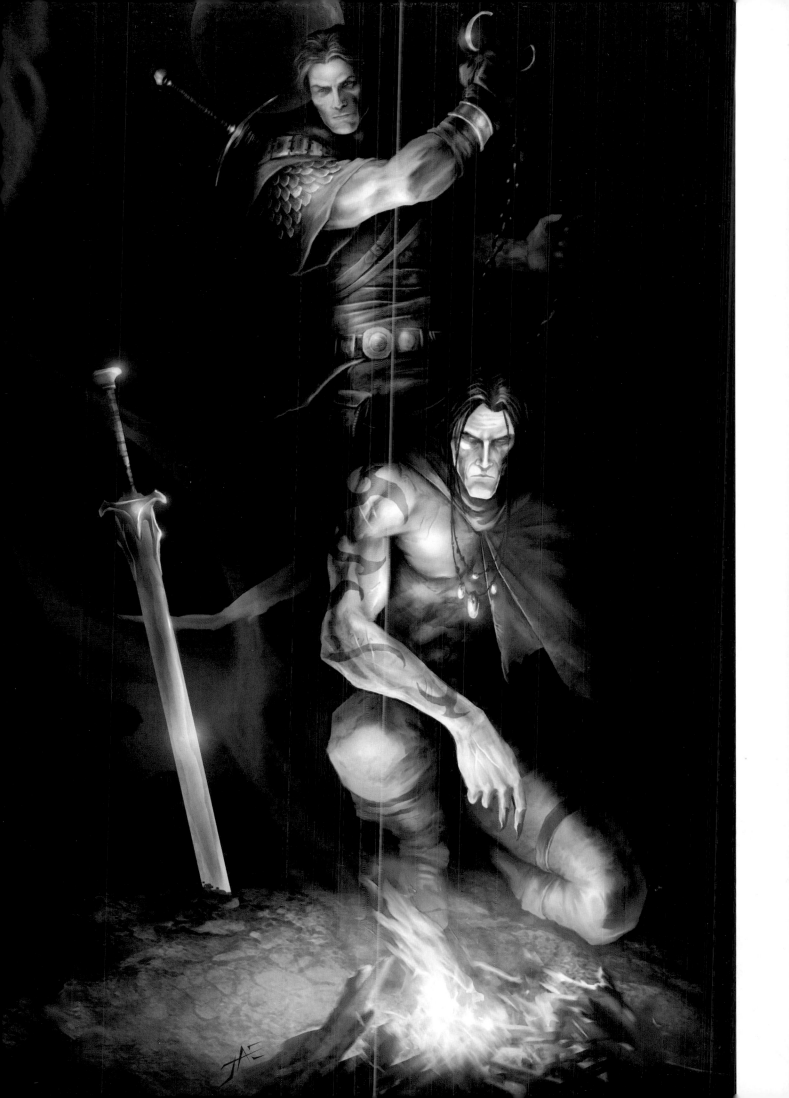

LUMINAIRE
2003, Digital, 3 x 10½ in
Dragon Magazine

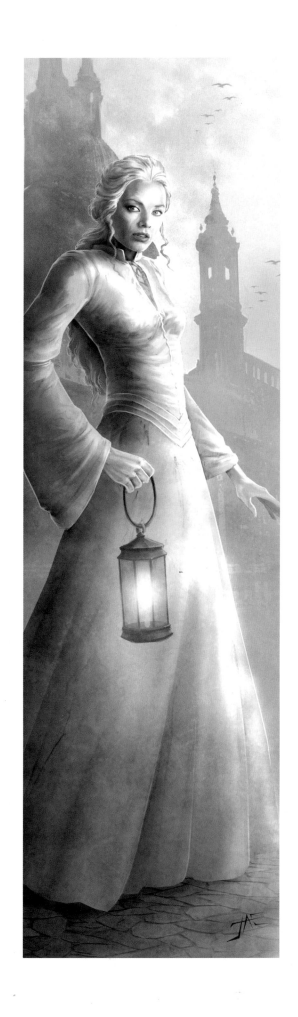

Facing page: **RANGERS**
2003, Digital, 8½ x 11 in
Dragon Magazine

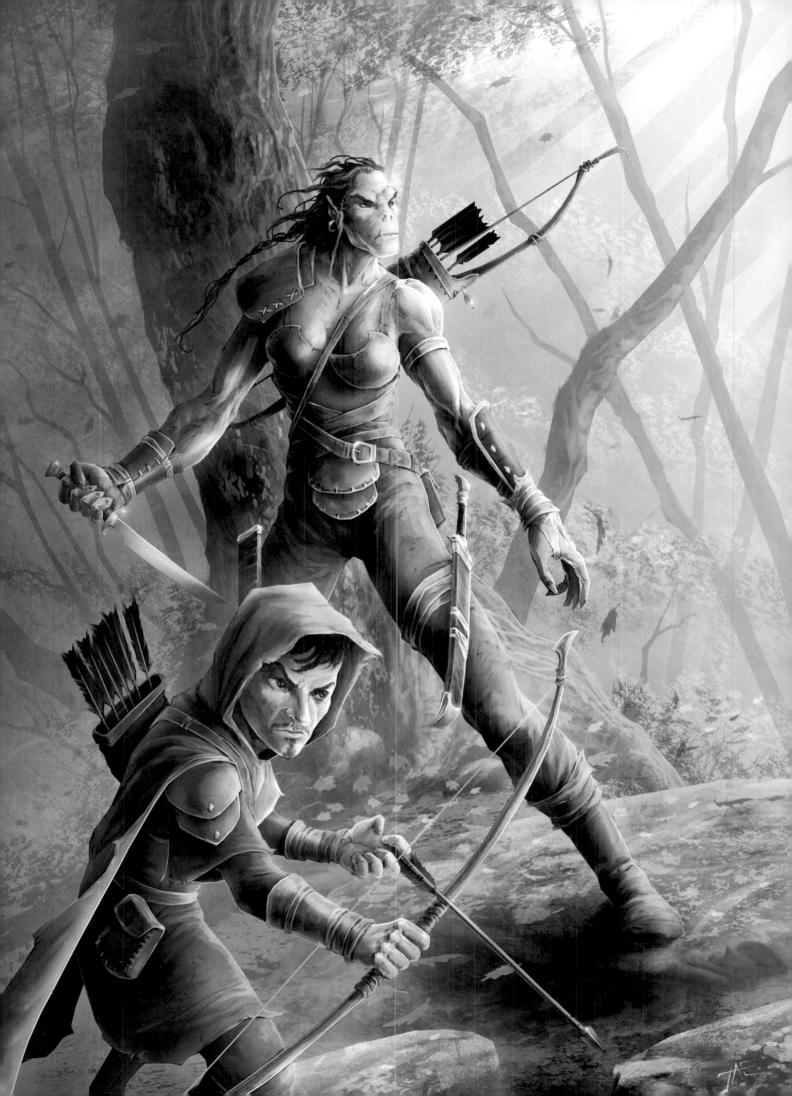

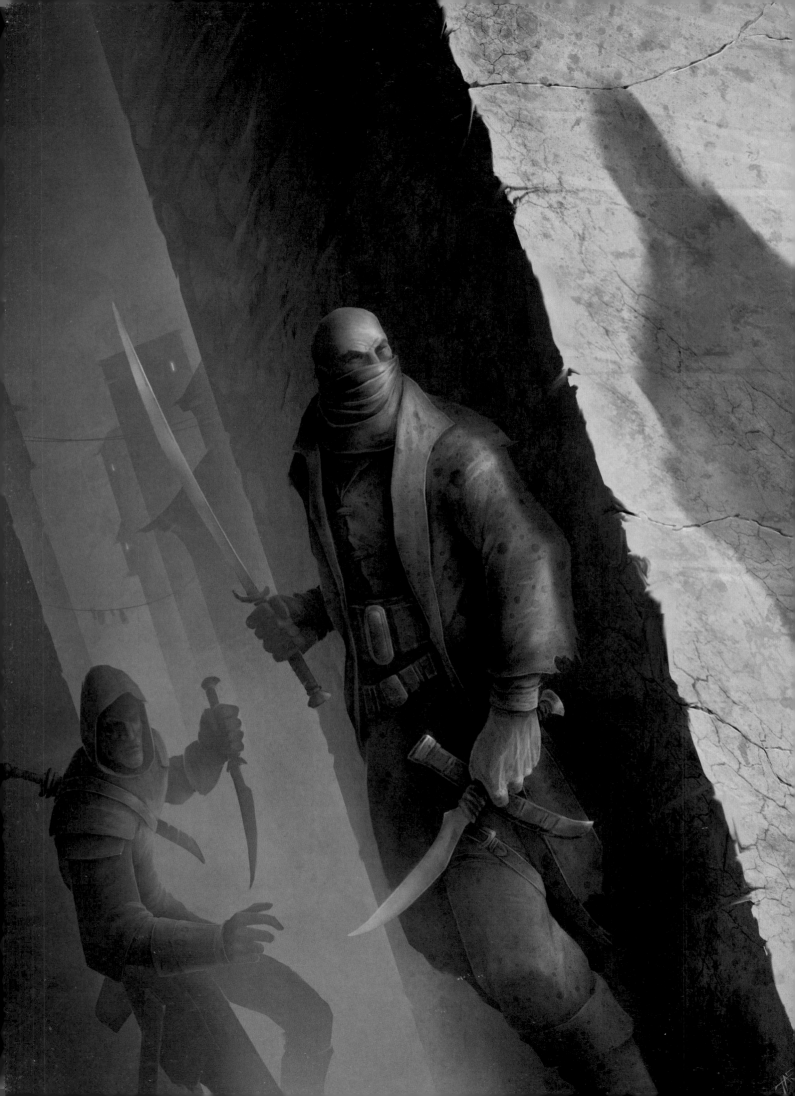

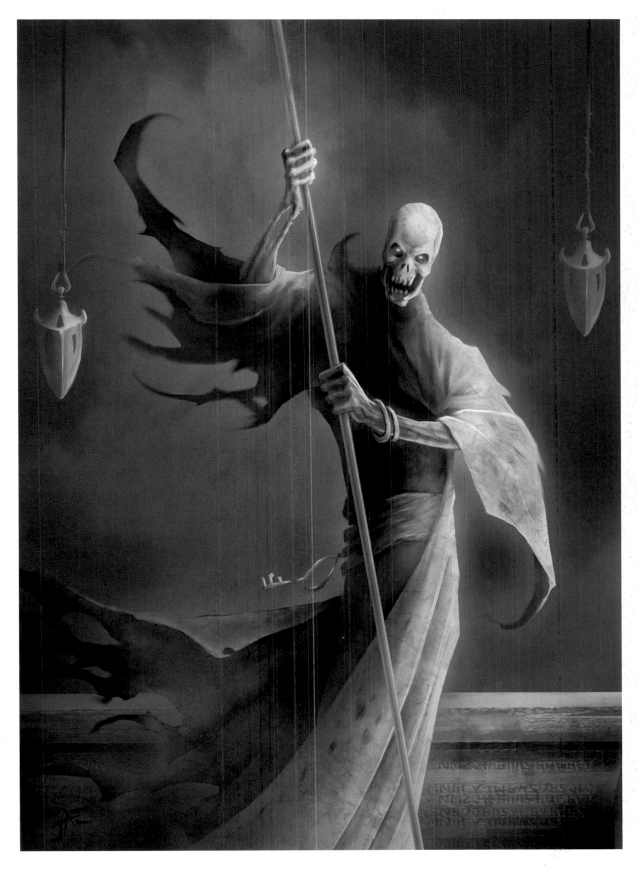

Facing page: ASSASSINS
2003, Digital, 8½ x 11 in
Interior for Dragon Magazine

REVENANT
2002, Digital, 5 x 7 in
Dragon Magazine

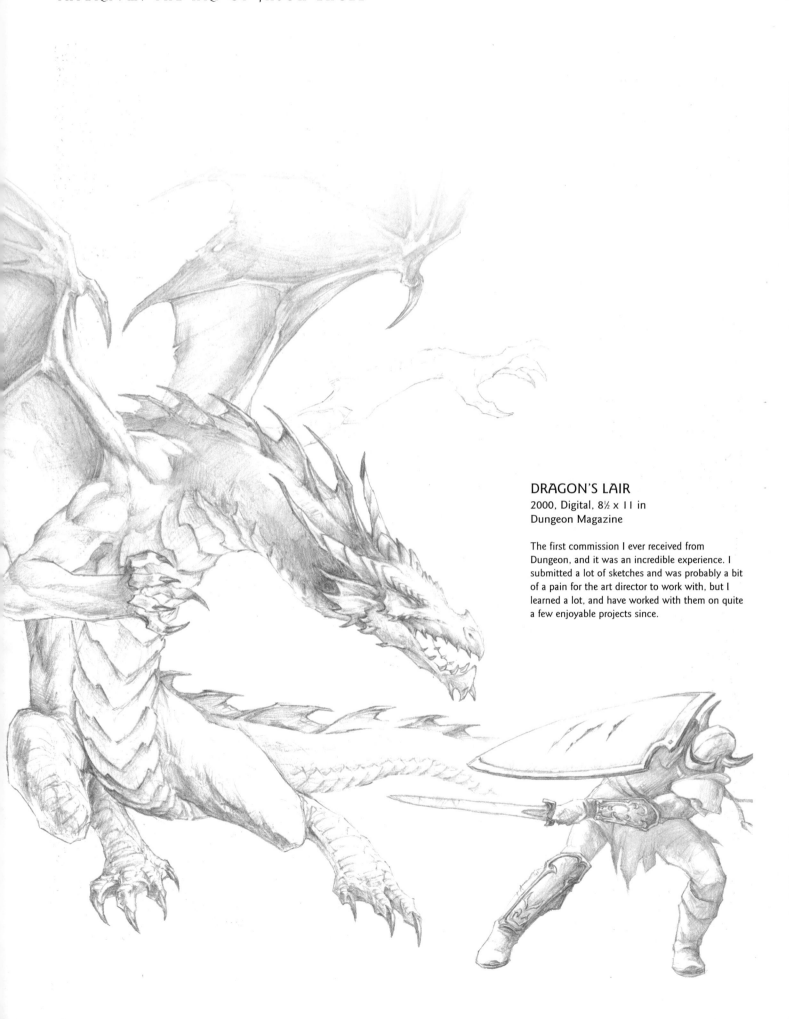

DRAGON'S LAIR
2000, Digital, 8½ x 11 in
Dungeon Magazine

The first commission I ever received from Dungeon, and it was an incredible experience. I submitted a lot of sketches and was probably a bit of a pain for the art director to work with, but I learned a lot, and have worked with them on quite a few enjoyable projects since.

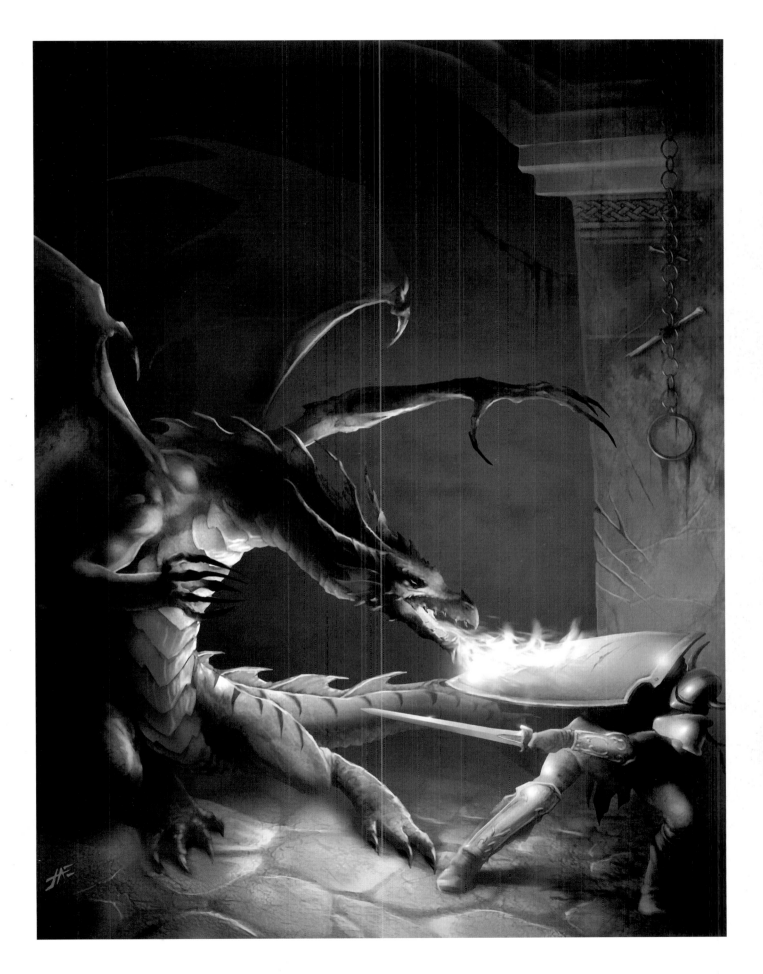

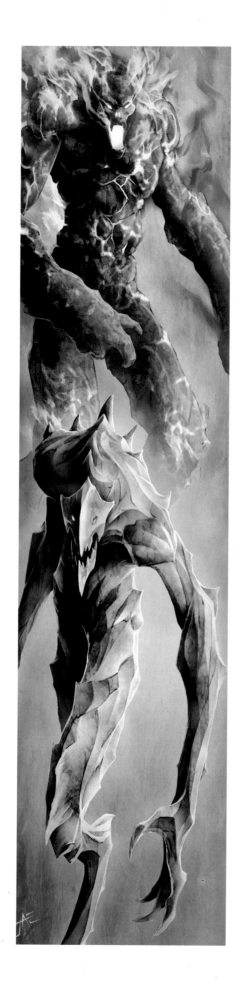

Facing page: **BLOODLINES**
2002, Digital, 4 x 8 in
Dungeon Magazine

DEVILS
2003, Digital, 4 x 16 in
Dragon Magazine

THE SEAL
2003, Digital,
8½ x 11 in
Talisman Studios,
Promo image for
'Legends Collection'

Facing page:
PARASITE
2003, Digital,
14 x 16 in
Dark Arts T-shirts

ANGEL

2001, Digital, 17 x 11 in
Promo poster for 'Legends Eternal' from
Emperors Choice

This was one of the first images I produced for
CyberGames, and it was intended for the promotion
of a line of miniatures being repackaged and re-
released with updated marketing and a cohesive
storyline linking the set together. But at the time I
was given the assignment, none of that had been
developed yet. So I was left with a completely blank
canvas, and all I had in the way of direction was
the idea that the image needed to be the exact
width of all the miniatures packs lined up next to
one another on a shelf. So I decided to go with an
image that presents a very epic, heroic fantasy
concept. Something that could be applied to
whatever story the writers and marketing folks
decided on.

DAVID & GOLIATH

2002, Digital, 8½ x 11 in
Interstrike

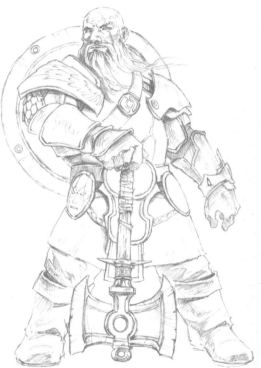

VALLEY OF KINGS
2003, Digital, 8½ x 11 in
Talisman Studios, Promo image for 'Legends Collection'

Facing page: **DREAMFALL**
2003, Digital, 8½ x 11 in
Self promotion

Every once in a while, I have the desire to paint something entirely different from the contracts I have on the drawing board. At those times, I usually take a break from my work, and paint whatever comes to mind. This has produced a lot of successes, like this one, and more than a few failures, which I won't be including in this book, but overall it helps me retain a certain love for the process. It's easy to get too involved in project after project, and art becomes more like a job and less like a hobby, which is exactly when the work starts to suffer. So I treat it like a hobby again every once in a while, and it kind of recharges my batteries, and reminds me of exactly what it is about art that I loved in the first place.

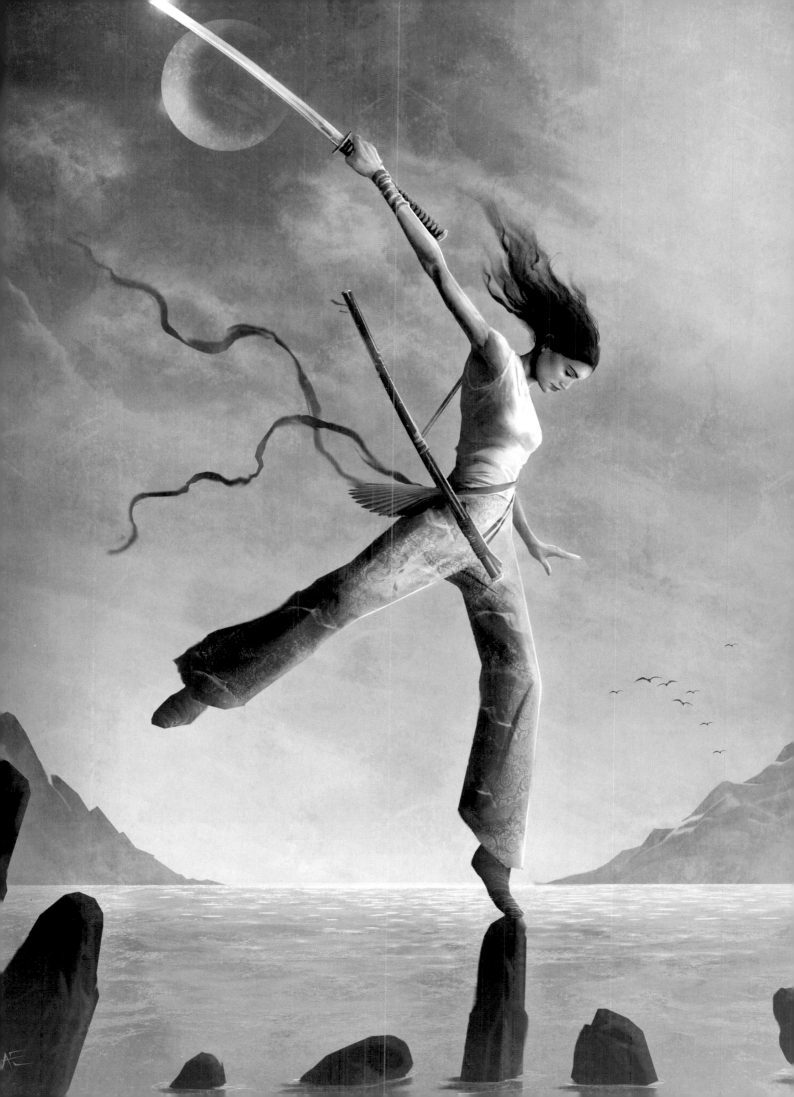

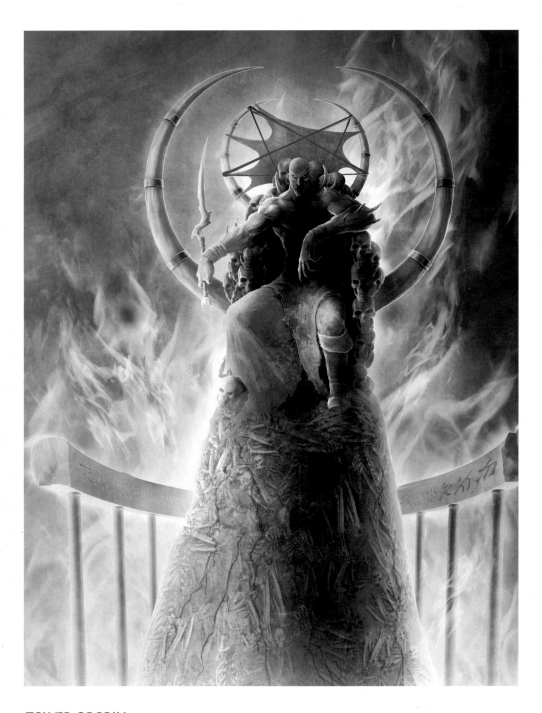

BIRTH OF HATE
2004, Digital, 8½ x 11 in
Personal promotion

I had just completed a series of character images for a line of dark fantasy T-shirts, and I needed a few new images to update my portfolio for the new year. At the time, I had been reading a lot of mystery and modern horror novels, so I used one of the characters from the T-shirt line, and threw it onto a background that seemed moody and darkly appropriate. It's always nice to take a simple, single shot character piece and turn it into a full painting, with a life and story all its own.

TOWER OF PAIN
2003, Digital, 8½ x 11 in
Self promotion

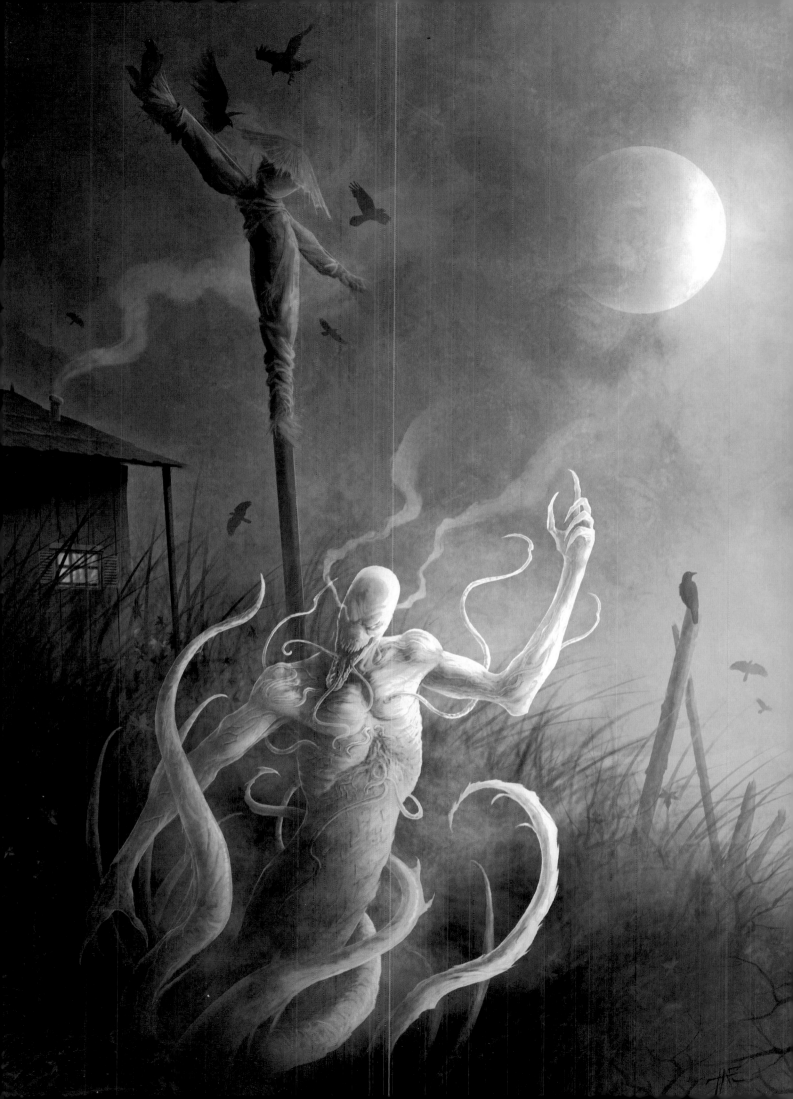

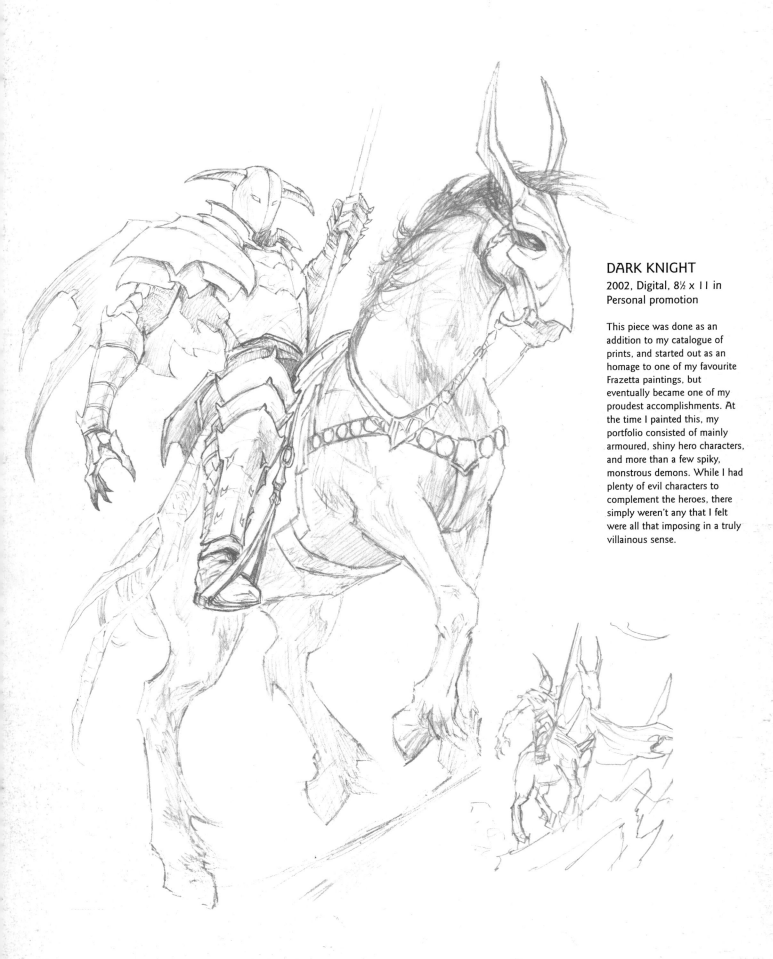

DARK KNIGHT
2002, Digital, 8½ x 11 in
Personal promotion

This piece was done as an addition to my catalogue of prints, and started out as an homage to one of my favourite Frazetta paintings, but eventually became one of my proudest accomplishments. At the time I painted this, my portfolio consisted of mainly armoured, shiny hero characters, and more than a few spiky, monstrous demons. While I had plenty of evil characters to complement the heroes, there simply weren't any that I felt were all that imposing in a truly villainous sense.

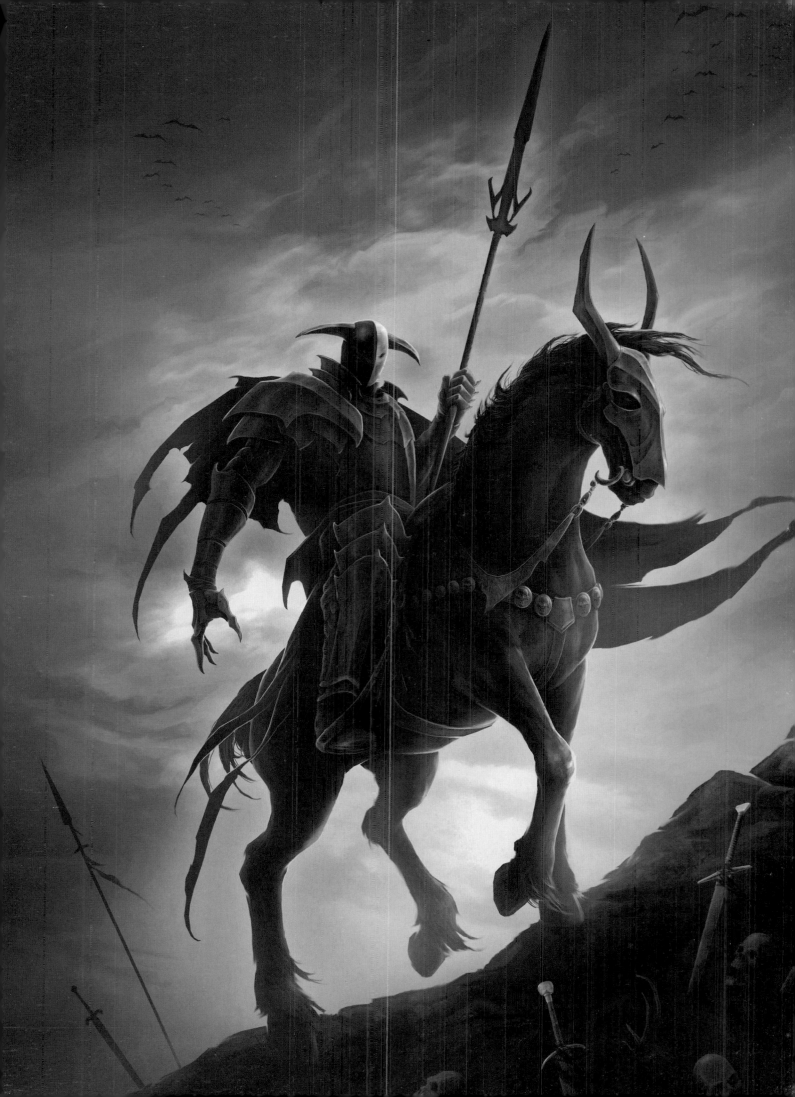

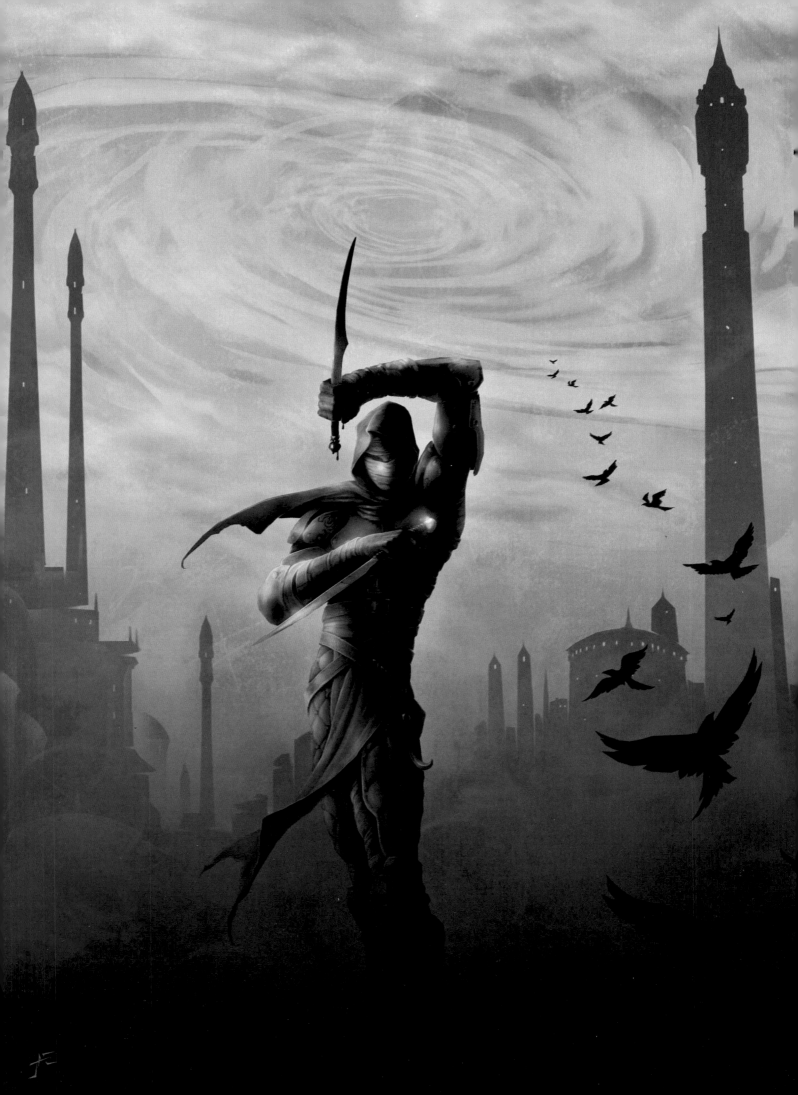

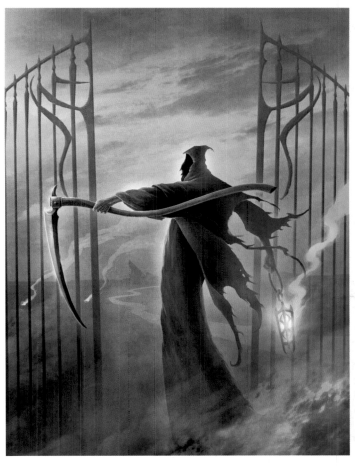

END OF THE ROAD
2004, Digital, 8½ x 11 in
Heavy Horses Records

Facing page: CITY OF TWILIGHT
2003, Digital, 8½ x 11 in
Talisman Studios, Promo image for 'Legends
Collection'

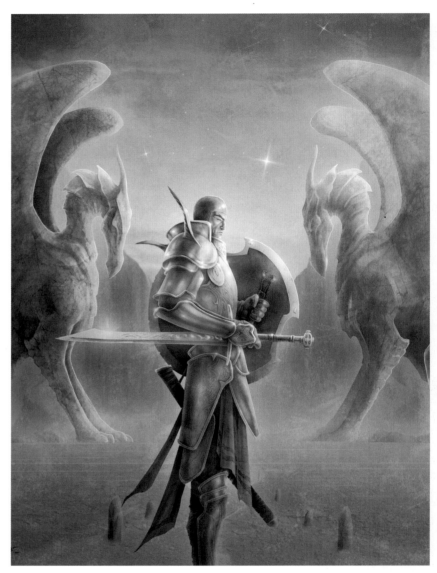

THE PATH
2003, Digital, 8½ x 11 in
Talisman Studios, Promo image for 'Legends Collection'

Facing page: **THE HUNTER**
2003, Digital, 8½ x 11 in
Talisman Studios, Promo image for 'Legends Collection'

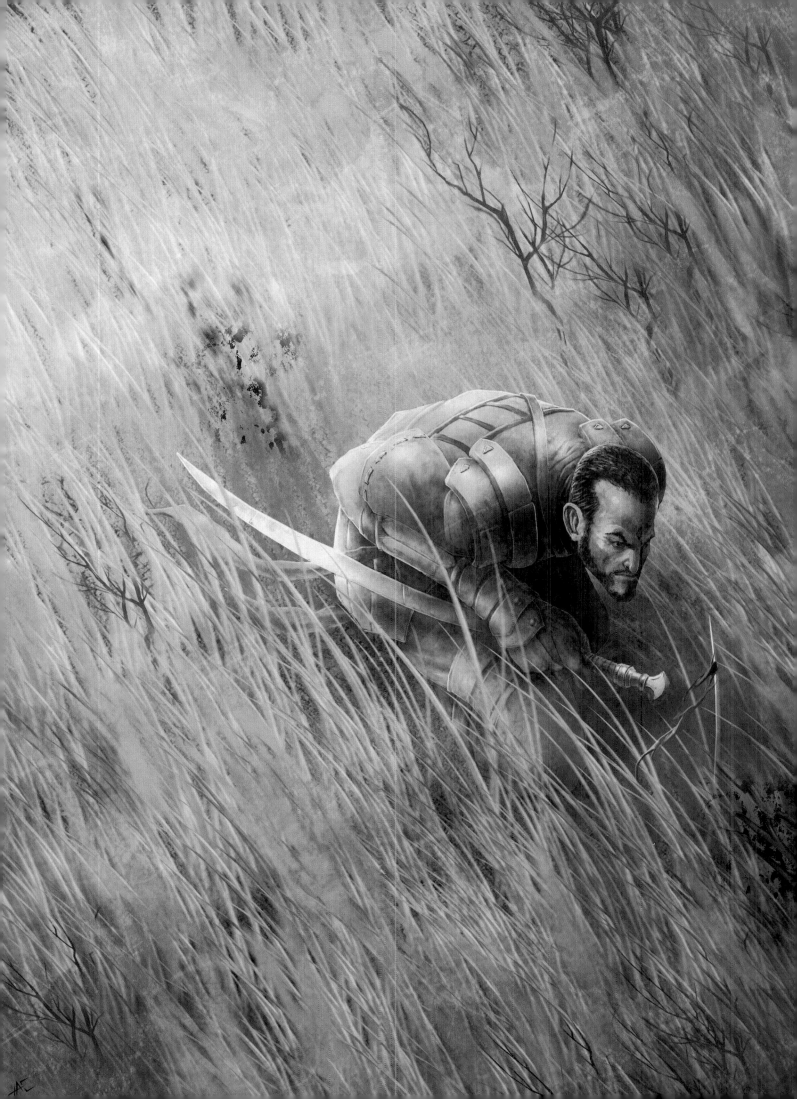

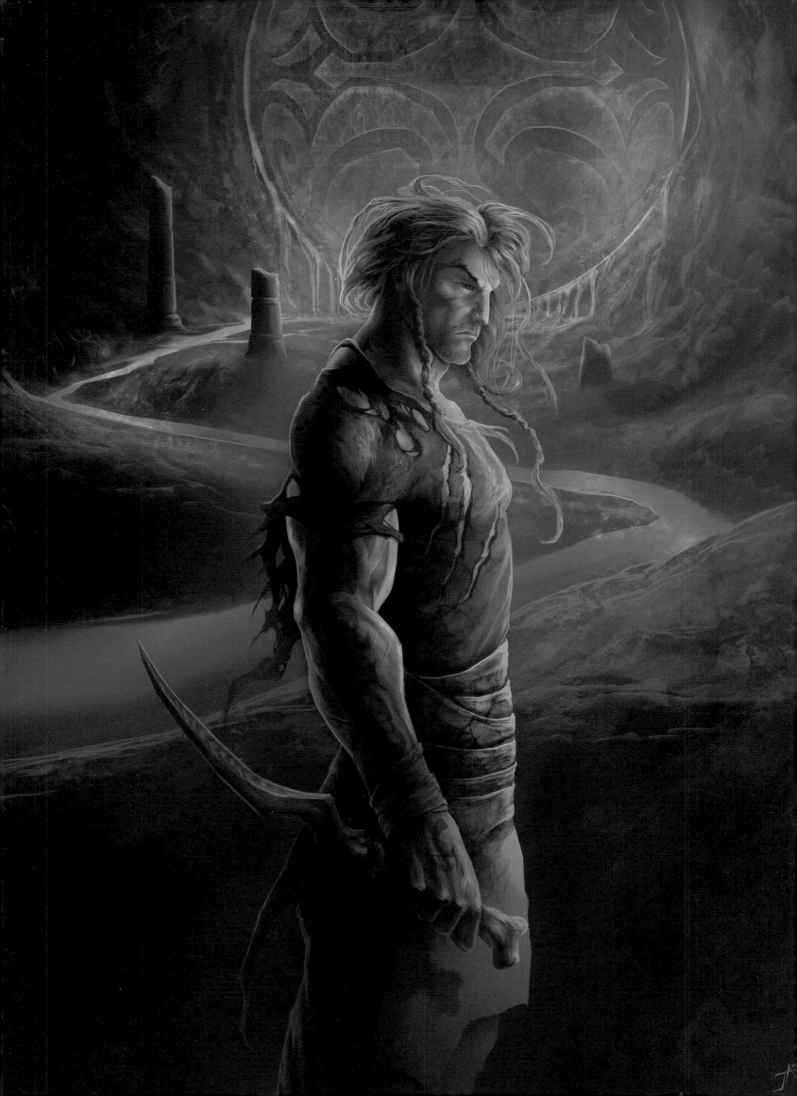

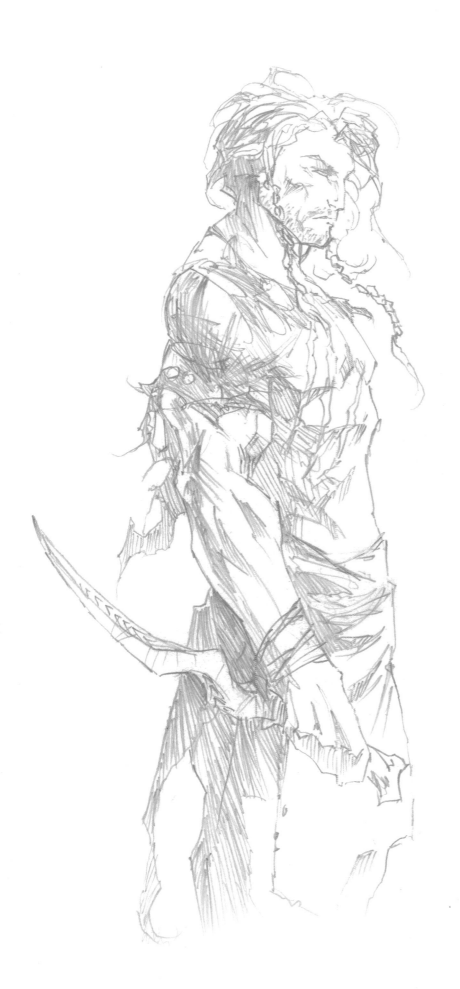

THE BLEED
2002, Digital, 8½ x 11 in
Personal promotion

Thumbnail composition sketch 1

Thumbnail composition sketch 2

Thumbnail composition sketch 3

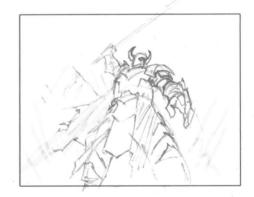

Thumbnail composition sketch 4

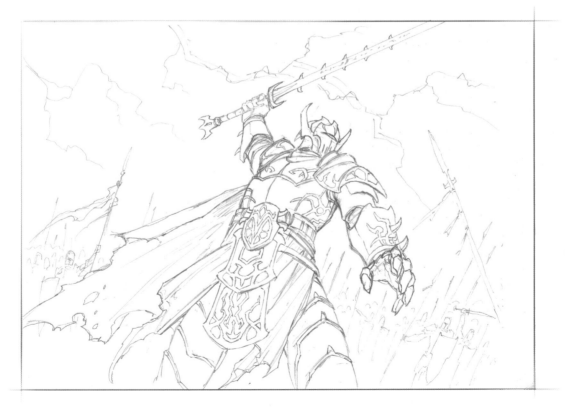

Full sketch

INSPIRATION & STYLE

Inspiration has usually taken the form of favourite movies, books, and, especially, other artists. As a child I would often find certain paintings to be so incredibly appealing that I knew I wanted to create something just as good. When I was still learning to draw, perhaps eight or nine years old, I first found a copy of the art of the Dragonlance saga. This book introduced me to many artists whose work would later become my inspiration and ultimately my aspiration would be to attain an equal level of excellence in the field of fantasy illustration. I spent many years studying and examining the pages of that collection, and have since found many more collections of great work to admire, but that book and the artists presented in its pages remain my single most profound artistic influence of youth.

In more recent years, my list of inspirational peers has spanned several different people in many genres of work, but as my preferred genre to work in is fantasy and science-fiction art, many of my current favourites fall into that category as well: Brom, Michael Whelan, Phil Hale, and of course Frazetta. And far, far too many more to list here.

I've always had a love for very gritty, surreal visuals, and any artist that can portray something that appears scary or intimidating, and still manage to tell a story in the image, is an artist I can admire.

I have always had a preference for the more heroic side of fantasy, in both fiction and art, and have found a very accommodating audience in the gaming and entertainment community. My tendency towards heroics and champions of virtue is no doubt due to my background in both gaming and fiction, but it is nonetheless my favorite subject to illustrate, and provides me with an endless supply of inspirational scenes and ideas.

I think, in the end, it isn't so much the opportunity to portray clichéd heroes saving the day and conquering evil, but rather the visual and moral contrasts that can be achieved in fantasy and science-fiction art.

THE METHOD

I'm primarily a digital artist, and my work process has developed around that. Here I've taken a selection of my recent work, and broken it down into steps to help explain my basic technique.

I start out with a number of thumbnail composition sketches in pencil, and pick the most promising, and render them out into several full sketches. I then send these to the client, and we evaluate the good points and bad points of each sketch, which can be occasionally frustrating, and finally agree on one for the image.

After that's out of the way, I scan the drawing into Photoshop, and begin rendering the image digitally, first as a black and white image to better establish tone and lighting.

I usually crop out the characters and main elements of the image, and darken them down to their dominant tone in relation to the rest of the image, and then start shading and adding shadow and definition.

After the basic lighting is in place, I begin adding highlights and hard lighting, and add in any remaining detail shading to help bring out the highlights.

Then I add colour, area lighting, effects, and any little composition fixes that I feel are just getting in the way. Once all that is complete, I pretty much just fiddle with it until I'm satisfied.

Scan the drawing into Photoshop

Add in any remaining detail shading to help bring out the highlights

Darken image down and start shading and adding shadow and definition

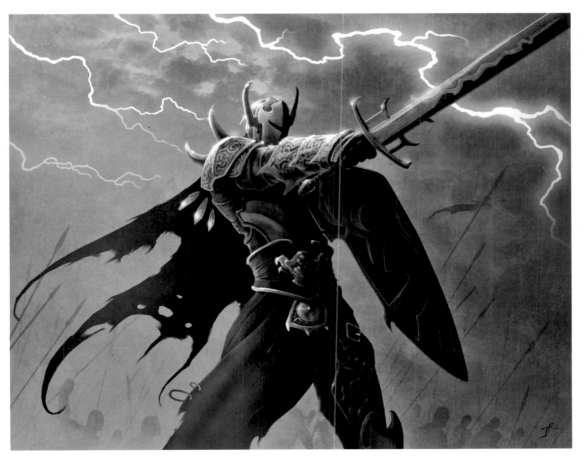

Add colour, area lighting, effects and finishing touches

INDEX OF WORKS

Acknowledgments

This book is dedicated to all the Obsidian folks, most of which I still keep in contact with, and all of which helped me earn the opportunity to live my life doing what I always dreamed I would. They are as follows: Jared, Sean, Ace, Jeannine, Kat, Mike, Ken, and Kevin.

Special thanks go to my parents – for always encouraging me when it counted (and giving me clothing and food and stuff).

Additional thanks go to the following people:
Adam and Wendy (for all the knowledge, inspiration and encouragement), Carlos (for keeping me entertained while growing up in a place more boring than most of you can imagine), all the talented people at Paper Tiger who helped put this book together, Nina (for allowing her husband the level of insanity necessary to do that gaming thing for a living), Jim Pinto (who perpetually owes me a beer for the rest of his life), Brom, Matt Stawicki, Frazetta, Todd Lockwood, Michael Whelan, Greg Hildebrandt, Keith Parkinson and Larry Elmore.

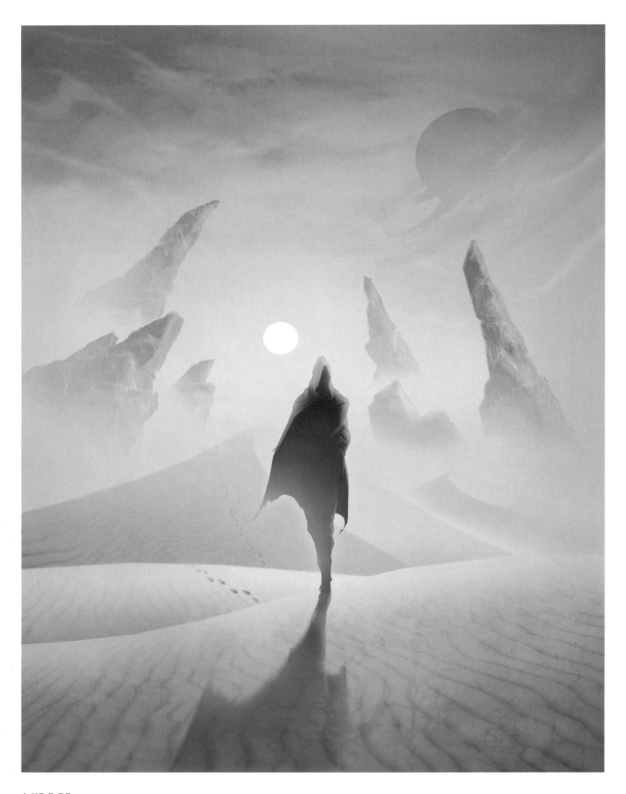

MIRAGE
2001, Digital, 8.5 x 11 in
Obsidian Studios, 'Shards of the Stone: Tangia' (unpublished)

This image was created for a story-driven sourcebook about a continent of
Arabic-inspired nations. However, the main antagonist of the story was of a rather
vague description, and a shape-changer. This presented a problem from an
illustration standpoint. So, I created an image that would convey something of the
character's mysterious nature, but with a light undertone of menace.